EFFECTS AND TRICKS

EFFECTS AND TRICKS

PAINTING

NIGHTSCAPES

WITH ARTIFICIAL LIGHT

JOSÉ M. PARRAMÓN

Overall manager: José M. Parramón Vilasaló
Texts: José M. Parramón and Gabriel Martin
Editing, layout and design: Lema Publications, S.L.
Cover: Lema Publications, S.L.
Editorial manager: José M. Parramón Homs
Editor: Eva Mª Durán
Original title: Pintando al óleo
Translation: Mike Roberts
Coordination: Eduardo Hernández

Photography and photosetting: Novasis, S.A.

First edition: April 2000
© José M. Parramón Vilasaló
© Exclusive publishing rights: Lema Publications, S.L.
Published and distributed by Lema Publications, S.L.
Gran Via de les Corts Catalanes, 8-10, 1º 5ª A
08902 L'Hospitalet de Llobregat (Barcelona)

ISBN: 84-95323-36-2

Printed in Spain

Table of contents

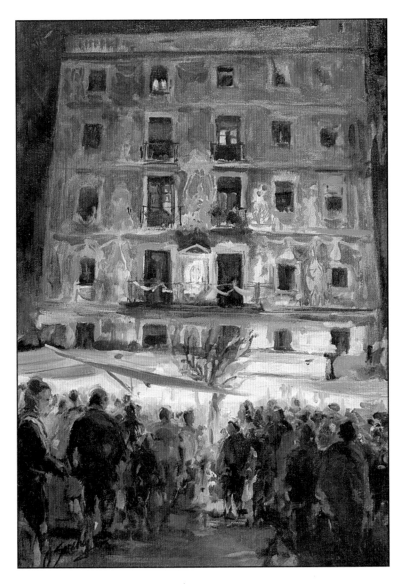

1

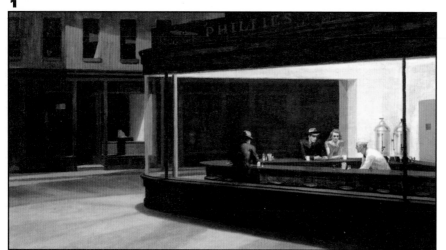

2

mon as a form of painting, which seems surprising considering the stimulating potential of the subject. Bustling city life –with lights from cars, the variety of colors of neon signs, the intricate network of illuminated facades, Christmas decorations, shop windows and the lights that filter through doors and windows– should be more than enough to stimulate any artist to work at night. It was not in vain that Baudelaire said the following in a poem called *Windows* in his collection *Spleen of Paris*: "There is nothing more profound, more mysterious, more fruitful, more shadowed, more shining that an illuminated window (...) What I was able to see under the sun is always less interesting than what happens behind glass. In that black or luminous hole, life is lived, life is dreamed, life is suffered".

Nighttime landscapes are not limited to city life, the same idea can be transferred to rural scenes (although it is clearly more limited): a view of a starry night, a moonlit landscape or even the edges of a path that is lit by oncoming headlights. However, one has to confess that an urban view of

3

When the sun falls below the horizon and when the flickering lights of street lamps, shop windows and cars headlights illuminate the world, many artists pack up their tools and go home. But night also provides the artist with an infinity of possibilities for producing worthwhile images. Several art academies and schools have recently started offering courses in nocturnal painting, and a considerable number of artists set up their easels (often fitted with little lamps) in city streets to explore the differences of painting urban landscapes when they are distorted by artificial lights.

This sub-genre is known as nocturnal painting, a style of composition with its own atmosphere and melodic qualities that are suited to the portrayal of nighttime scenes. This is a popular theme in the musical world, but far less com-

Fig. 1. **Nighthawks,** *by Edward Hopper (Art Institute of Chicago). The light from the building floods across the whole scene. This painting reflects urban solitude, as seen so often through indiscreet windows.*

Introduction

illuminated streets and buildings is the main attraction of nocturnal painting.. It seems that night causes landscapes to have an almost phantasmagoric appearance, with undefined outlines and confused forms. Nighttime figures are painted with gentle, sinuous lines and nocturnal tones are lyrical and refined, singularizing the pastoral character of paintings drawn between the falling and the rising of the sun. Nocturnal landscapes give us the chance to explore the presence of dim, failing lights and we can detect the presence of vibrations that cannot be felt when the sun is shining down from the sky above. City lights and lunar reflections draw everything they shine upon away from the norms of reality. Unknowingly, paintings become fantasies that are symbolic interpretations rather than naturalist representations.. Inexperienced painters tend to avoid nocturnal themes, but the paintings shown on the following pages show just how stimulating their potential can be. I urge you, like so many artists before you, to learn to appreciate the value and creative potential of pain-

ting nocturnal scenes. I sincerely hope that this book can be of assistance in teaching you how to deal with lighting effects and to get around the many difficulties that can occur when one attempts to paint landscapes under such peculiar lighting conditions.

Gabriel Martín Roig
Art critic

4

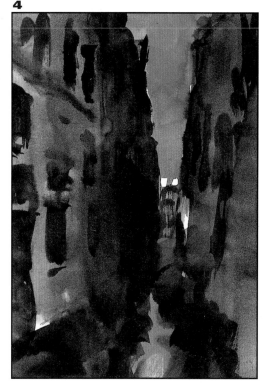

Fig. 2. **Nocturnal: blue and gold. Saint Marks in Venice,** *by James McNeill Whistler (National Museum of Wales). The suppression of details is inherent in Whistler's nocturnal paintings. Many years later he commented that: "I think this was my greatest nighttime painting".*

Fig. 3. **Winter night in the mountains of Rondane,** *by Harald Sohlberg (Rasmus Meyer Collection, Bergen). The artist puts emphasis into the contrast between the two planes; the night sky and the white snow. This strong contrast of color lends the illuminated snowy mountains a majestic character, almost as if they were cathedrals of ice.*

Fig. 4. **Darkness in the canal,** *by Manel Plana (Artist's private collection). The main components of this piece are the dark facades, the two street lamps right at the end of the street and the fresh, intense darkness of the reflections on the still water.*

Fig. 5. **Palace Square in the snow,** *by Darío de Regoyos (collection belonging to the Belgian Royal Family). The artist paints nightfall over the Royal Palace in Brussels in the middle of winter, with all of the street lamps lit and a carriage pulled by donkeys passing by.*

5

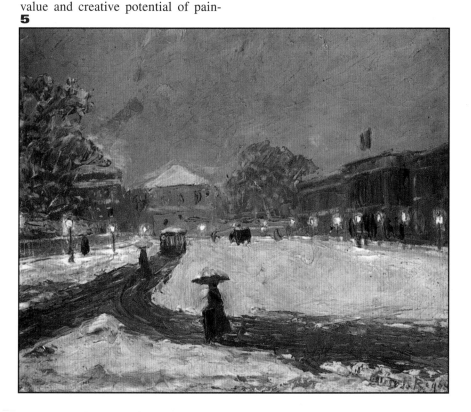

Nocturnal painting through the ages

The Venetians were probably the first people to paint nocturnal scenes on a regular basis, and one of the leading exponents in the field was Tintoretto. Night features strongly in one of his most famous works of art, a painting called *Transferal of Saint Mark's body* (fig. 1). In this highly agitated composition, the main protagonist is really the storm that breaks out in the middle of the night and introduces a marked contrast between the group of figures in the foreground and the planes that move into the distance in an exaggerated perspective. Venetian painters did not deal with night in isolation, but used it as a backdrop for many of their mythological compositions. In Spain, El Greco, one of the greatest inheritors of the tradition formed by the Venetians, painted *Toledo in a storm* in the year 1600. It is a view of the Castillian city under the unreal looking light of the moon, managing to create a mysterious, symbolic dimension of a city smothered by the blackness of the night (fig. 2). Nightfalls, storms and nocturnal themes seen by moonlight were also common subjects in the work of the Dutch painters of the 17th century, whereby the effects that such phenomena caused in the sky became more important than the landscape itself.

It wasn't until a few centuries later, and in particular the Romantic period, when nighttime scenes came back into fashion. During the Romantic period, night was rarely seen in a positive way, and when it was it was usually the presence of the moon that suggested it, signifying that the moon removes danger from the night and turns it into a time for love –the moon being the source of melancholy and solitude. Nighttime scenes suggest indecision, fear, anguish, sadness and danger– all that which prevails in the troubled mind. Examples of this can be seen in the paintings by the American Thomas Cole and the German Caspar David Friedlich, shown on these pages (figs. 3 and 4). The latter's paintings get their messages across through the subtle use of light, a consequential but alarming vision of life, preferably expressed through misty or nocturnal landscapes.

The main concern of the Impressionists was the quality of lighting effects as they

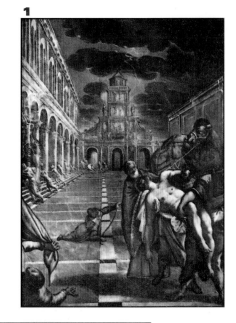

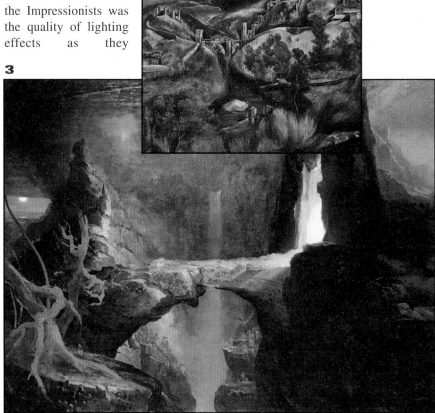

Fig. 1. **Transferal of Saint Mark's body,** *by Il Tintoretto (Gallery of the Academy, Venice). The Venetians were the first painters to represent the night as a dramatic, desolate element, and this gave way to a new way of dealing with light and color in landscapes.*
Fig. 2. **Toledo in a storm,** *by El Greco (Metropolitan Museum, de New York). Clouds cover the sky in this landscape, and it looks more like the city of Toledo is being seen under the moonlight than suffering the effects of a storm.*
Fig. 3. **The expulsion,** *by Thomas Cole (Thyssen-Bornemisza Museum, Madrid). In this nocturnal view, the artist accentuates all the elements that suggest terror of the abyss, the unchained forces of nature and wastelands being tormented by the spirits of destruction.*

constantly changed on the surface of objects and nature. As well as their way of transferring such perceptions to canvas, it is by no means surprising that they also turned their attention to nocturnal urban landscapes within large cities and interior scenes lit by artificial light. The symbolist and impressionist painter Henri Le Sidaner, in his painting *The hut on the edge of the forest*, exploits one of his favorite aspects: the effects of artificial light on the dusk atmosphere through the use of small, warm sources of light that concentrate all of the light in the scene (fig. 5). Divisionist painters like Seurat, van Rysselberghe, Regoyos and Luce were also interested in the effects of light and color and showed them in optical combinations that used pointillist techniques. Luce in particular painted nocturnal scenes in which the appearance of a mysterious moon added a dramatic presence to quiet, peaceful buildings (fig. 6). The Spanish painter Darío de Regoyos, a keen follower of both impressionist and pointillist masters, continued such studies with his landscapes seen at different times of the day in portrayal of the different lighting patterns. From very early on in his artistic career he showed remarkable skill in interpreting light in different spaces, but his greatest passion was for the effects of artificial light on nocturnal views, and this can be seen in an enormous number of his greatest works (fig. 7).

As we have seen in the brief overview that this chapter has offered, the representation of nocturnal landscapes has had a rich and varied history. There are so many other artists that have not even been mentioned: Van Gogh's starry skies, Whistler nightscapes and the vibrant artificial light in the work of the Italian Futurist painters. But to cover them all would need far more extensive study than we have space for here. Perhaps in another book...

4

5

6

7

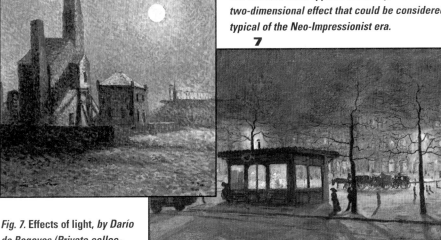

Fig. 4. **The moon rises over the sea,** *by Caspar David Friedrich (National Gallery of Berlin). We see a placid sea with lines of color that reflect the moon as it appears from behind the clouds on the horizon.*

Fig. 5. **The hut on the edge of the forest,** *by Henri Le Sidaner (Carmen Thyssen-Bornemisza Collection). Within the range of colors that are veiled and neutralized by a white mist, the blue walls of the hut shine through, as does to an even greater extent the window lit by a spot of yellow-red light.*

Fig. 6. **Factory in the moonlight,** *by Maximilien Luce (Carmen Thyssen-Bornemisza Collection). The brushstrokes, applied uniformly, create a two-dimensional effect that could be considered typical of the Neo-Impressionist era.*

Fig. 7. **Effects of light,** *by Darío de Regoyos (Private collection). This was one of the artist's first nocturnal pieces, and is a worthy attempt at painting the interaction between lights and the shadows that they cast. It shows the square at the station in the north of Brussels..*

Artificial light and the color of objects

Objects do not have one fixed and invariable color, the spectral composition of the color stimulus always depends on the spectral composition of any existing light. When we vary the color or intensity of the source of light, the way we see the color of objects can be modified considerably. Natural daylight is bluish in color, while the artificial lights that illuminate city streets tend to be yellow or orange. This means that the yellowish light of streetlights has a direct effect on the objects that it illuminates, making them appear different and alternating their colors. When the color of a light is changed, the color of any objects changes too. For example, a red object lit by a green light will look black, a blue object lit by yellow will

look more violet, a green object under orange light will appear brown and a red object under yellow light will seem to be more orange. This effect is not exclusive to nighttime scenes, because sunlight also affects the color of objects. It can make colors and tones more tenuous or intense, depending on whether there is blazing sunlight, an overcast sky or if the sun is rising or falling.

Artificial light is not as variable as daylight; it is constant and controllable. The tungsten light of an incandescent bulb, which tends to yellow colors, makes colors seem warmer than they really are. You can buy special "daylight" bulbs that imitate the bluish light of the north, colder and more realistic. White fluorescent

Fig. 1. The yellowish light that appears in the streets of so many modern day cities spreads a clear shade of orange over the buildings. See how the white of the houses and the gray of the asphalt seem to have been dyed by a sienna orange.

Fig. 2. See how, in this photograph, taken in a little seaside village, the colors of the boats have been affected by the orange lights. The ultramarine blue of the boat has a more violet tendency, green seems darker (the net almost looks brown) and red is more orange.

Fig. 3. At Christmas time, our streets are decorated with a multitude of lights that compete with those that exist all the year round.

1

2

3

lights not only blend lights and sources of light but also falsify the color of objects, making local colors seem brighter. It is not surprising, then, that this is the kind of light that butchers and florists like to use, because the exaggeration of the natural color of their products makes them look even more inviting. These are the three basic kinds of light that can be found, although there is also an endless supply of colored bulbs and filtered lights that can create new effects on the color of objects.

As you know very well, the stronger the light, the more saturated colors will be. When light is less intense, it is only logical that the brightness of colors will also weaken. The total absence of light causes black, but softening lights does not necessarily mean that colors blacken in paintings. You should forget the idea that the darker your subject is, the more you will need to use black. There are many other ways of darkening colors and the use of black is one of the least important.

Good painters, before starting to paint, should be able to see the chromatic tendency of their subjects and use them to interpret what they see more artistically. A scene under yellow or orange light tends to have more harmonious color throughout, and you should try to exploit this fact.

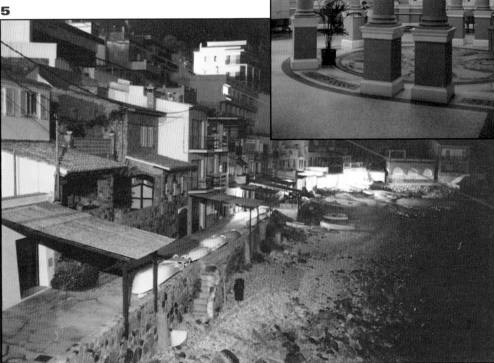

4

5

6

Fig. 4. Lights with whiter tendencies do not have such profound effects on colors. See how the effects of color are less contrasted in this picture, and the light appears more diffused.

Fig. 5. The absence of intense sources of light creates an almost monochrome effect. An example is this view of Cala Margarida in Spain where the weak street lamp and the light of a few houses hardly illuminate the scene at all.

Fig. 6. The lights in buildings used for entertainment and leisure tend to be extremely colorful and the decoration tends to make everything seem even brighter and more spectacular.

Light and the casting of shadows

Projected shadows are one of the most important features of any landscape or interior whose main source of light is an artificial one. The shadows that objects cast create strange and marvelous forms that can create interesting dynamic effects in a picture by drawing attention to certain aspects of the illumination, portraying a better sense of space and guiding the spectator's eye around the surface of the painting.

The shadows produced by artificial lights, normally much more distorted than those produced by regular sunlight, are cast in a straight line from a point just under the source of light that continues outwards. If you look closely at a streetlight, you will see how the artificial light spreads radially, which implies that the shadows of the objects and people around it will also be projected radially. They will always point away from the source of light. These shadows are well defined when they are near to the source of light and get more diffused the further away they reach. When you paint a shadow, remember that the edges of shadows created by artificial lights are not so strongly contrasted as those produced by direct sunlight. The lighter outer shadow is called the penumbra, or half-light, and the darker central shadow is known as the umbra. The larger and more intense the source of light, the smaller the umbra will be.

Shadows should be painted with dark colors although this does not have to imply the use of black. You can also use gray or brown. Shadows as local colors are not made up of just one hue, but of several. The colors of shadows also include the complementary colors of the object whose image is being cast. For example, as the complementary color of yellow is violet (the mixture of the other two primary colors, red and blue), there will be a hint of violet in the shadow of a yellow object.

In many cases, an object will be lit by more than one light, so the shadows create unlikely, overlapping forms with different tones. If, when you are painting

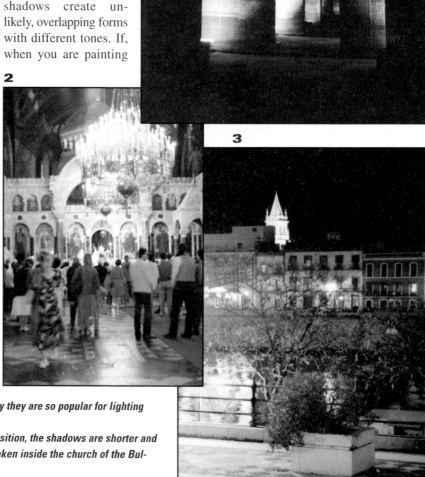

Fig. 1. Artificial lights near the ground can produce spectacular shadows that fill architectural structures with sinister shadows, which is why they are so popular for lighting such buildings as this Egyptian temple.

Fig. 2. If the source of light is situated in a high position, the shadows are shorter and less visible. You can see the effect in this photo taken inside the church of the Bulgarian monastery of Rila.

Fig. 3. Notice how the plants in the foreground cast a blurred, unclear shadow, suggesting that the source of light is quite far away. The further away the source of light, the less defined the shadows will be.

a scene, you find that the number and form of the shadows make the composition difficult to understand, you should calculate each of the lines beforehand as part of your preparatory sketch. Draw a straight line from the base of each light along the edge of the shadow, making sure that it coincides with the edge of the object that is casting the shadow. These lines will continue until they intersect with any other light that is cast.

The impact of nocturnal paintings increases when they include watery surfaces, because they act as reflectant surfaces, filling areas of shadow and highlighting areas of darkness. Rivers and the sea are transformed by night, and become areas of reflected lights, increasing and detailing places that would otherwise be lost in the dark.

4

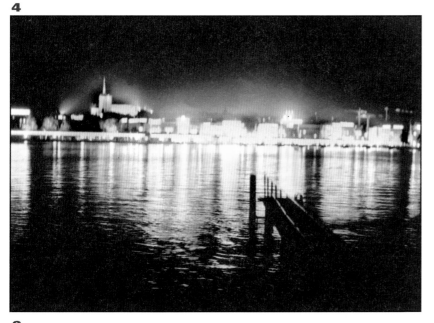

Fig. 4. Water and the reflections upon it almost always make the effects of a painting more attractive. Look at the explosion of color on the surface of the lake in this Swiss town.

Fig. 5. Fox dens on the shore of Lake Derwent (section), by Joseph Wright of Derby (Derby Museums and Art Gallery). Looking at this section of Wright's painting, you will see how the light of the lantern spreads radially and therefore how the shadows it casts are also radial.

Fig. 6. Night in St.Cloud, by Edward Munch (Nasjonalgalleriet, Oslo). Shadows do not necessarily have to be black or gray. In this painting by Munch, the shadow cast onto the ground by the window frame is full of blues and violets. If you look at any of the corners of the room, you will see how a multitude of different tones and colors merge in the form of short, brisk brushstrokes.

6

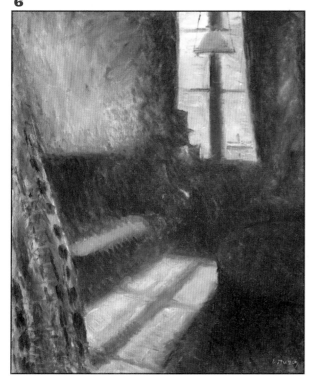

5

How to paint rays of light

The ability to paint rays of light has always been admired by amateur artists, but it is actually quite an easy technique to perfect. To paint rays of light, you first need to understand that artificial light travels radially and in a straight line. So, you need to paint the bulb or light source with bright colors and make their rays gradually darker in the form of a degradation as they move outwards. The resulting image should show a light with a circular halo that degrades from more intensity to less from the center outwards, as if it were an aura (fig. 1). As I have already explained, the different types of lights used for illumination can produce different color effects. Sodium, tungsten and quartz sources produce orange tones and a more intense halo of light. Mercury and fluorescent lights create colder tones and more diffused halos, which range from white tones to green ones.

In many cases, the ray of light can also be seen to be directed by a spotlight, becoming a shaft of light. In such cases, you need to paint with lighter, more intense colors where the ray is closest to the source of light and soften the color by spreading and diluting its form as it travels further away (fig. 2). In an interior painting, the main problem is that nowadays there are so many different types and designs of lampshade available that direct and distribute light in hundreds of different ways. The most common is a conical

shade that interrupts the flow of light and directs it downwards, making the light seem broken into bright outlines that distinguish the most brightly-lit section from the area in the shadow (fig. 3).

As you can see here, we have suggested a few solutions, although the best thing is to observe carefully and think about lighting in each individual case. Once an artist is able to assimilate what there is to be seen, it will be easier to translate lighting effects onto paper or canvas.

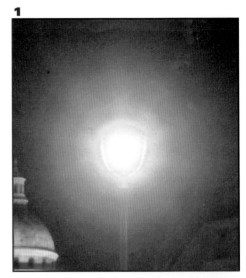

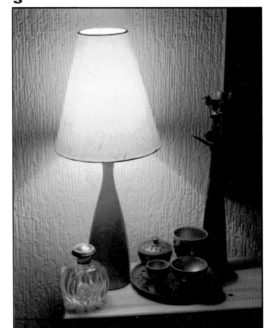

Fig. 1. Looking at this lamp, we can see the characteristic halo of light that is formed around it.

Fig. 2. When rays of light are directed by a spotlight, you should start painting with more intense, bright colors from the origin of the light and soften and degrade the color as it gets further away from its source.

Figs. 3 and 4. Lampshades interrupt the flow of light from a bulb, and at the same time, redirect it. The form of the light depends on the form and design of the lampshade.

The artist's palette: chromatic limitations

To paint a nighttime scene you will need a similar palette of colors to one that you would use in the daytime, but you will use the colors differently. If a daytime landscape includes a lot of red, orange and yellow, at night these take on a secondary role. Nocturnal landscapes need more blues, browns, grays and violets. It is clear that it will always depend on the artist's interpretation but in general, this will be the case. The most popular range is one of cool colors. Warm colors such as reds, oranges and yellows tend to be used in more specific places to suggest sources of light.

As much as possible, avoid using black to darken the colors on your palette. Limit your use of black to only when it is strictly necessary. In fact, once you have practiced and experimented with the use of color, you will find that black is not a vital factor in the darkening of colors. You can combine far more interesting sets of colors, such as blues and browns, reds and greens or oranges and blues. Any of these three mixtures create more interesting dark shades than those that you would make by mixing with black. For example, if you want to darken a blue you have several options: adding carmine will make your blue look more violet, while if you add burnt umber to blue it will look very similar to black.

When you paint, colors should relate to each other on the surface and harmonize with the image as a whole. Painting nocturnal

scenes does not have to imply that the picture is going to tend towards gray and black. It could also have a red, green, violet, blue or any other tendency. Harmony is crucial, the colors of a composition need to fit into the whole image and to be compatible with each other. While contrast accentuates the expressiveness of the theme, harmony is pleasant and peaceful in the spectator's eye.

1

2

3

4

Figs. 1 to 3. In these three illustrations we can see three different harmonious ranges being used in nocturnal paintings: a range of blue tones in **Blue and gold nocturnal** by James Abbott McNeil Whistler (Tate Gallery, London) (fig. 1); a harmonious range of red colors in **Steelworks in Cardiff** by Lionel Walden (National Museum of Wales) (fig. 2); or a more yellow tendency in **Landscape in the moonlight** by Jacobus Theodorus Abels (Boijmans van Beuningen Museum, Rotterdam) (fig. 3).

Fig. 4. The nocturnal painter's palette should be the same as that used for painting in the daytime. However, each color will be used differently, with blues and dark grays playing far more important roles.

The first nocturnal lights

We are going to paint a series of exercises that describe the scene at the very end of the day, when the sun is low on the horizon, when shadows get longer, when the sky gets darker and when the lights start coming on in the streets of towns and cities. Our first invited artist is Jean Diego Membrive, and the subject is a wet side street in a village on the Basque coast in the north of Spain (fig. 0). We will be using oil paints. This painting needs to be done quickly because the lighting effects will not take very long to change, unless the artist takes a photograph and continues work in his stu-

dio or decides to return at the same time on another day.

Fig. 1. For the preparatory sketch, the artist decides not to use charcoal or pencil, and uses a brushload of burnt umber with a lot of thinners to draw the main forms of the composition directly into the picture. He uses plain, linear, synthetic lines. As you can see, the artist works with a

dry English red wash. Colored backgrounds at this early stage help the

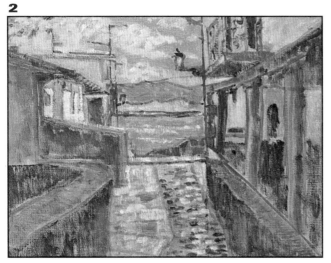

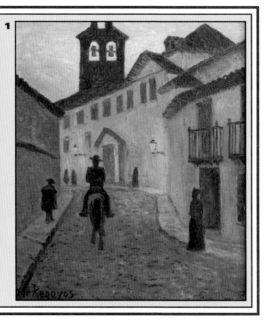

MODELS

1-. *A street in Cordoba*, by Darío de Regoyos (private collection). This painting by Regoyos shows us how interested this artist was in the failing light of sunsets, able to allow for the vibrational presence of the first streetlights to come on, something impossible to detect when the sun in the south of Spain is shining at its strongest.

artist to create the first tones that are going to define the overall atmosphere of the piece. In this case, he has chosen a warm color that will help to reflect the warmth of the light as evening starts to fall.

Fig. 2. Initially, the artist plans the main areas of shadow with the same burnt umber that he used to sketch the main outlines of the composition. Use this color to paint the wall in the bottom left hand section, the balconies and columns of the house on the right and its corresponding reflection on the wet street. At the same time, add a little cobalt blue to dirty this color. With gray colors work on the areas that are still in the shadow and use titanium white for the reflections on the ground and the clouds in the sky. With

a grayish green do the same for the hills that appear on the distant shore. As you can see, the artist used brisk, synthetic stokes on dry to suggest the dynamism of the light coming from the sea.

Fig. 3. When he has finished preparing the chromatic definition of the picture, the next step is to accentuate the contrasts and put body into the different features by adding color and texture. With a mixture of raw umber and black, he accentuates the darker areas, blending his strokes to intensify the loss of detail in the areas that are not lit directly. With this in mind, highlight the facades of the wall and the houses by contrasting darkness and creating an effect of depth, thinking about perspective and the relationship between proportion and size. Draw

the details of houses, such as the columns that will help you to clarify the foreground, the balcony and the land in the distance, with a thin brush and this same mixture. You should be able to understand how the areas in the middle ground that fall under the shadows of the houses are not so dark and therefore include richer patterns of shades. The foreground seems more evidently counterlit.

Fig. 4. Now the artist works on the texture and reflections on the surface of the stony street. To do this he uses

TIPS

1-. When you are drawing your preparatory sketch, you can correct your lines and redraw them as often as you need. If you ever find that a whole section needs rectifying, you can wipe it clean with a cloth soaked in thinners.

2-. Although a painting over a medium tone background can have less tone than one painted over a white background, the advantages with respect to speed and the accuracy of modeling forms, as well as the appreciation of colors and tones, help to compensate for these minor effects.

light impressionist and overlapping strokes of ochre, black and grayish ultramarine blue. The most intense reflections are painted with similar white strokes. The artist continues, defining linear contours (to highlight forms) and applying light touches of

MODELS

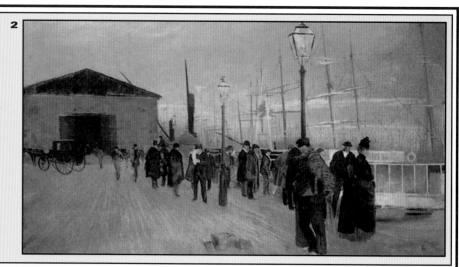

2-. *Figures on the bridge*, by Ramón Casas (Fundación Deu Font, Vendrell). This second model also shows a port when the first streetlights are coming on as night descends. These are little more than small spots of light without halos because the failing light of day is still more intense than the light given out by the gaslamps.

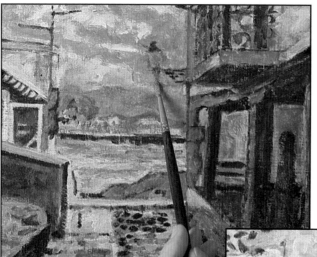

strokes. You may be surprised that some of the colors he uses at the start of the painting, such as the ochre for the houses, are disappearing under the grays of the shadows, but this is how the artist gets that chromatic richness and stops the image from looking too flat and uniform.

Fig. 6. The painting is nearly finished, but the foreground still is not strong enough. The artist adds new strokes to the paving stones and darkens the wall on the right and the porch to the house with new violet and gray strokes. Notice how, compared with the previous steps, the surface of the painting is far more varied. This is particularly true of the houses, where the stokes in the most shadowy

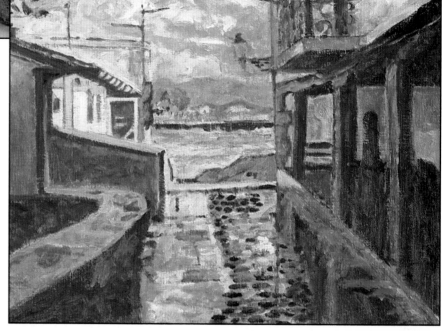

English red and ochre to the facade of the house on the right so that they contrast with the cold atmosphere of the picture as a whole. A few thick, dense areas of the same English red with gray-violet are used to paint the large boulder behind the boat.

Fig. 5. Membrive now works on the light of the streetlamp that has only just been turned on. He paints the bulb with a uniformly orange wash, and then paints an aura around it with that same orange and cadmium yellow.

He insinuates some elements of the background landscape and the interposed atmospheric effects with light

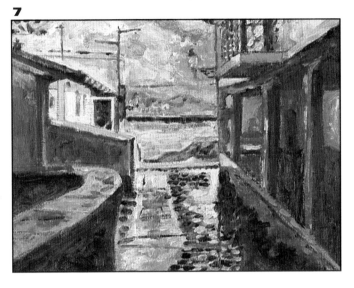

on the left and the clouds in the sky, and he applies loose areas of paint when he constructs the paving effects on the ground. Notice how his brushstrokes follow the direction of his forms and volumes, with colors and short, multi-directional strokes in the clouds, and he paints vertically and horizontally when he comes to any architectural elements

Fig. 8. As you can see from the finished work, the unequal, broken quality of dry strokes can be highly expressive. This is a particularly adequate technique for suggesting textures and describing natural effects such as the stones walls, rocks, the effects of the sky, clouds or the way that lights shine upon water. The bright brushstrokes and the broken effects of color add a sense of move-

ment to the piece as a whole, suggesting the fleeting qualities of light and shadows as they constantly change. So, apart from creating an attractive surface with a lot of character, the way in which strokes are applied also contributes to the overall definition of the subject.

areas contrast with the denser pastes of paint in the sky and puddles of water. As you can see, the grain of the material breaks the strokes and produces a pleasant texture.

Fig. 7. This is the definition and correction stage, and so a smaller brush is used. The artist applies long, linear strokes to touch up the balcony, the coastline and the architectural elements. He uses irregular lines for the reflections on the pavement, the wall

8

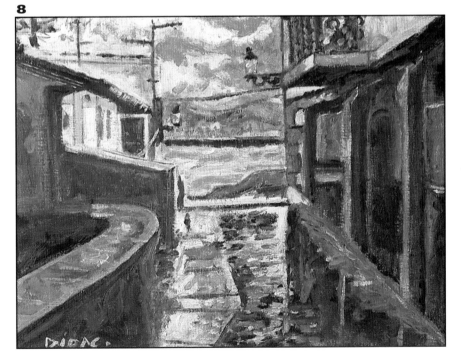

View of a coastal town

A nocturnal view of Palamós, a small town on the Spanish Costa Brava (fig. 0) is the subject that the painter Teresa Trol has chosen to paint with oils alla prima. This is an excellent technique for working outdoors because it means you can finish the whole painting in just one session. The freshness and spontaneity of the results are very attractive and require a sure technique – given that there is no preparatory sketch or outlining. The painting is to be completed *alla prima*, which involves painting everything in one session. Before starting, Teresa Trol takes a

few minutes to think about the aspects of the subject that she is most interesting in showing. As you know very well, nocturnal paintings need to use colors and light in very different ways to daytime ones. As the lights are artificial, they create a certain atmosphere and contrast in the scene that they are illuminating, even the colors are more diffused and take on similar values of tone. Teresa Trol is going to take all of

0

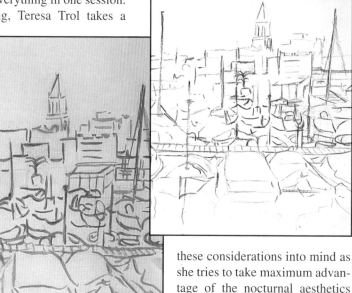

the boats in the foreground and middle ground and the houses in the background. Notice in this initial sketch, the accuracy with which Teresa has reflected the relationships between the proportion and space between the different elements that make up the image, because the layout of these first shapes will have a direct influence on the colors that she adds later. In this opening phase, Teresa has indicated all of the main features, knowing that too much detail now would lead to confusion as the painting progresses. One has to start off with a synthetic, simplified image and make it more complex as the painting develops.

2

1

these considerations into mind as she tries to take maximum advantage of the nocturnal aesthetics that she is about to represent.

Fig. 1. The artist starts the landscape with a charcoal sketch of

MODELS

1

1-. *Moonlight in the port of Bologna*, by Édouard Manet (Orsay Museum, Paris). The light of the moon gives the artist the chance to play around with sumptuous blacks and whites, as well as the silhouettes of faceless figures that appear in a scene with a mysterious air.

3

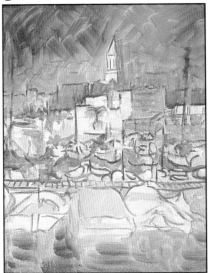

Fig. 2. Once the drawing of the figure has been sketched, the main lines of the drawing need to be perfected. The drawing needs to be particularly well defined for this particular exercise before any color can be used. The outlines drawn with a pencil are profiled with a brush dipped in a little thinners, but be careful not to use too much or the color will run on the surface of the painting.

Fig. 3. The next intervention of color is made with paint that is slightly weakened with thinners. A little scoop can help when you apply oil paints, particularly because you will be able to finish the first stages of the painting much more immediately and quickly. Dampen the brush in thinners and dilute the color on your palette. After draining the brush so that the color does not run on the support, start painting the forms of each of the elements of the picture. As you can see, the ar-

4

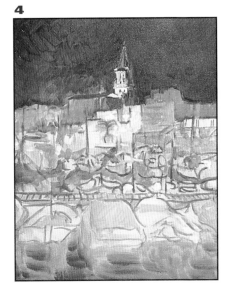

tist does not use strokes that are either too greasy or excessively opaque, so that any corrections can easily be made by passing a brush soaked in turpentine essence or pure thinners over the problematic area. The mixture has been made with warm tones: ochre, sienna, raw umber and cadmium red. As early as this first wash, Teresa situates the gradations of light and dark colors that appear in the model.

Fig. 4. Once the main areas of the painting have been painted with generous quantities of thinners, it is time to move on to more specific features. The artist has deci-

5

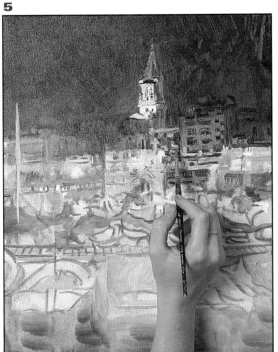

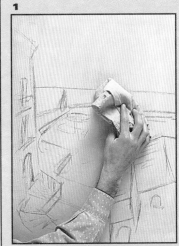
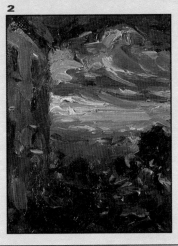

MODELS

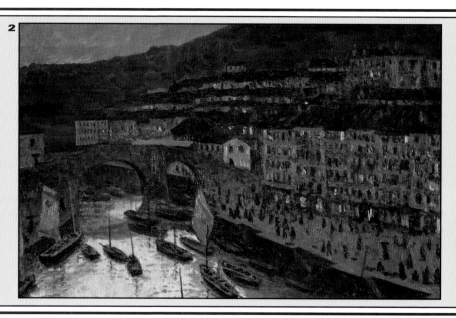

2-. *In the port of Onda-rroa,* by Darío de Rego-yos (Private collection). This sunset reflects night-fall extremely accurately. The artist centers his attention on the facades of the houses with their lights recently turned on. All this is achieved through the perfect use of pointillism.

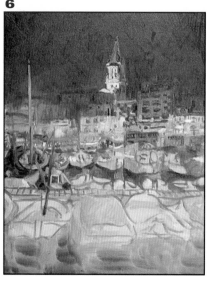

ded to work from the top downwards, beginning, naturally, with the sky and finishing off in the foreground, the closest part to the spectator. She paints the sky with a mixture of burnt umber and violet. The paints should be thick and carefully applied to avoid coloring the area that is reserved for the line of houses, which should still be white. With a small, round brush, construct the voluminous effect of the church tower, using very white paint to distinguish the illuminated face from the shadowed one. Similarly, work on the outline of the church tower and the

details of its architecture.

Fig. 6. With the same small, round brush that you used to start the exercise, darken the facades of the houses by means of several washes in succession (made with a brown with certain dark gray tendencies). Notice how the roofs of the buildings are somewhat confused with, and sometimes even blend into, the color of the sky. With the help of a small, round brush, Teresa paints the forms of the doors and windows with just two or three superimposed strokes of a slightly more intense brown.

Fig. 5. Although the construction of the painting is being based on fragments of color, the artist takes care over tonal relationships. An example of this is the repetition of the dark color used for painting the sky and the orange tones that appear in several parts of the image, and the surface of the water in the middle ground that reflects the color of the sky. This water has not been painted uniformly, but also contains other colors such as yellow, green and red,

although it is somewhat softened by the adjacent presence of the burnt umber that has been used on the surface of the water.

Fig. 7. The definitive forms of the boats in the middle ground have been painted with a combination of areas colored with linear strokes made with the tip of the brush. In this way, ochre, violet, green, yellow and gray strokes

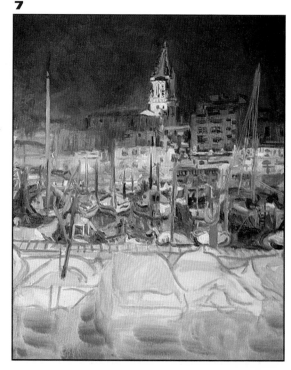

8

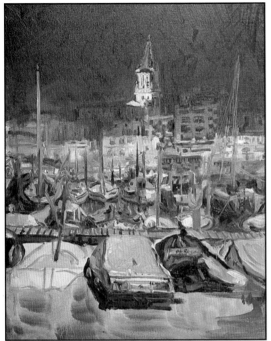

the paper. The other one in the center is still just a sketch. There is contrast between the diluted and concentrated paint, as well as between the skillful touches and lines of the brush. This artist uses her fingers to paint as well as her brushes, and you could try doing the same.

Fig. 9. Teresa paints the surface of the water with different mixtures of colors: violet and red for the nearest section to the boats, touches of emerald green for the reflected color of the boats, and for the darkest part of the foreground she uses a mixture of black and violet. This is no uniform mixture; there are several mixtures and different vigorous strokes that are superimposed on wet. The color should be fairly thick, and not too diluted so that it does not run too easily and leaves a sensation of slightly pasty colors. To apply a thick color onto another one that is wet, you

are superimposed. The colors used here are not pure, but somewhat neutral, in other words, they are combined with dark gray colors that reduce the intensity of the color. There is no attempt to produce an exact replica of the model, neither the boats nor any other feature have been painted in too much detail, but at this point the composition works well enough to portray the atmosphere of a peaceful port at night quite effectively.

Fig. 8. We are now working on the foreground, and it is time to paint the nearest group of boats. With an emerald green and a neutral yellow, paint the motor boat in the center alla prima. Using violet washes do the same for the boat on the right and the other that appears on the left of the picture, right at the edge of

9

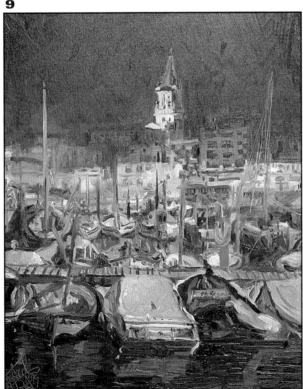

TIPS

3-. Coloring wide areas helps with the development of a painting. It is a good idea to color areas before you apply details and build forms that are originally based on undefined strokes.

4-. The *alla prima* painting method was most popular during the Impressionist period. To work wet on wet for the longest possible time, the Impressionists used a semi-drying opium oil.

3

4

need to fill your brush with plenty of paint (too little and you would only dirty the color). The finished painting shows how she has tried to recreate the warm atmosphere and romanticism of nocturnal illumination, along with the fluid movement of the water. To get results like this, it is important to work freely and spontaneously right from the start, and not to have any fears of making mistakes.

Street lights

We are now going to see how Óscar Sanchís paints a side street illuminated by the tenuous glow of streetlights. In this painting the artist uses an original approach through the use of neutral colors, in other words, colors that are slightly altered to represent the effects of light and shadow that are caused by street lights. The model is fairly picturesque, being a photo of an Easter procession going along a street in Seville, Spain (fig. 0). The technique that will be used for this exercise is watercolor.

Fig. 1. He starts with a simple pencil outline sketch, a drawing that will assist with the development of the watercolor. It is fundamental that the lines, however discreet, are correctly positioned before starting on the painting itself. The artist starts with the foliage of the tree with thick violet colors mixed with ochre that are already exaggerating the tones of the model so as to get the right lighting effect. The best way to start working is with thick strokes, preferably free and uninhibited.

Fig. 2.The ochre-yellow wash applied to the wall in the background (on the illuminated facade) is painted with what is an apparently quite simple

technique. It basically involves taking color with a damp brush, and spreading it with even more water so that it degrades. The degradation is blended into the background when its

0

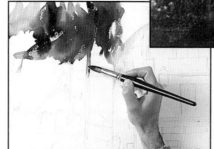

1

2

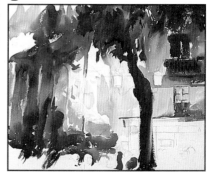

transition with the white of the paper is practically identical. The counterlit shadow cast by the tree, which is in the foreground, can divide the illuminated part of the facades into suggestive forms. Meanwhile, tonal contrasts like these promote the space in the foreground of the painting to

3

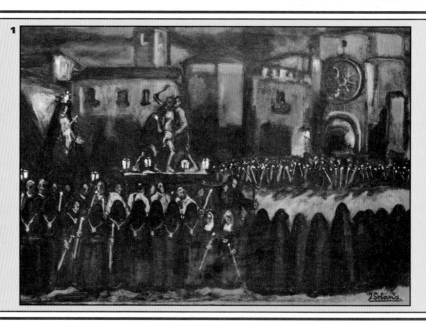

MODELS

1

1-. *Procession,* by José Gutiérrez Solana (private collection). This painting is made up of different objects seen under streetlights on a dark night. The pattern of colors is not very varied: blue and black dominate, with spots of light that bounce off the street lights and the illuminated faces.

4

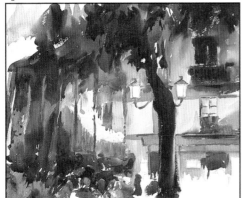

give the whole image a sense of depth. With the same color that was used for the tree, paint the balconies.

Fig. 3. The most illuminated areas are left to the white of the paper. At this stage, the artist shows how it is not necessary to paint objects and forms in too detailed a way; the context is enough to suggest the information needed to understand the details without the need of defined and figurative forms. See how the forms of the procession are already appearing, although the Virgin Mary has not been represented yet. Despite the free, uninhibited treatment of these early phases, the outline sketch is still the main guide to each area, and this should remain true throughout the whole watercolor.

Fig. 4. Make a transparent gray-violet wash to paint the shadow of the facades of the houses. With a small, round brush you should now represent the forms of the streetlights, and the handles that are used for holding up the procession images and effigies. The streetlights should stay white

6

(unpainted), and isolated from your strokes. With rough, abstract strokes, paint the crowd of people at the bottom left of the picture. For this section, the artist paints wet on wet, in other words, he paints over or cleans the colors while the paint beneath is still damp.

Fig. 5. Now with a small brush paint a few more of the details, These should be free, flowing strokes and not too accurate. They will not run as long as the colors beneath have dried properly. Represent the blurred form of the crowd and start forming the figure of the Virgin Mary lit by an enormous number of candles. Remember to leave the candlelit spaces white. The blending effects of wet on wet can be applied

5

along with the effects on a dry base to show depth, the texture of the facades, the crowd of people and the forms of objects. Take care to always use neutral colors. A luminous red color surrounded by shadows would have a negative effect on the painting.

Fig. 6. Keep working on the figure of the Virgin Mary, but the image does not need to be too realistic and short superimposed strokes recreate the effect of the light of the candles. This is where we end this simple exercise in which we have been able to put several basic wet on wet techniques into practice, something that we will be returning to in later watercolors. As you can see from the finished painting, the artist has managed to correctly repre-

sent this scene lit by the weak illumination of streetlights. Notice how the base of the painting is visible in many parts of the picture, helping with the harmony of the piece. The process is then completed by returning to the original sketch with black-violet strokes that are applied with a small brush.

Moonlit landscape

Here is one of the most typical Romantic themes: a moonlit landscape. Moonlight produces very different lighting effects to artificial light. To start with, the clouds in the sky play a very important role, also being lit by the moon. In this exercise we are going to be working with an artist called Grau Carod, who has years of experience of painting nocturnal scenes and is the perfect candidate for a study of the effects of moonlight. The model is an excellent combination of a full moon, though it does

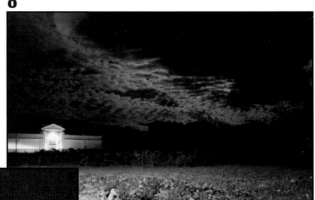

0

1

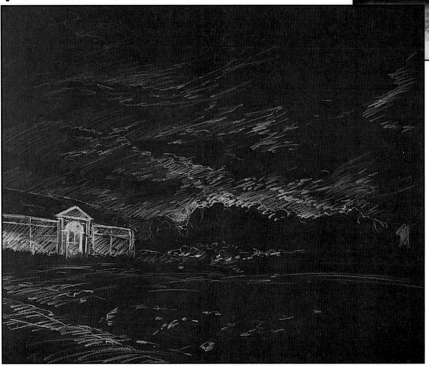

not appear in the picture, with the light of a distant cemetery and a street lamp (also out of our field of view) that lights the little path in the foreground (fig. 0). Grau Carod will be using a limited palette of oil paints Fig. 1. By choosing to use a black background, the artist can use the support as his base background, determining the tonal intentions of the scene he is going to paint right from the start. He starts drawing the scene with a white pencil. As he plans the fit, he situates the horizon in the lower half of the picture, making the sky more important than the rest of the landscape. Using pencil lines, the artist determines the first lighting effects that will be completed as the painting progresses.

Fig. 2. This next step involves establishing the basic tones of the landscape, making sure from the beginning that the value of each color relates to the others. This avoids any discordant or isolated colors from altering the desired harmonious effect of the image. With a mixture of titanium white and cobalt blue, he starts defining the mass of clouds, working with diagonal strokes that maintain the dynamism of the preparatory sketch. He then uses ochre and white to color the facade of the cemetery and applies a few cadmium yellow strokes to the vegetation. There is greater evidence of green here due to the contrast provoked by the black base.

Fig. 3. Keep painting the sky with a

MODELS

1

1-. *Almería beach by night*, by Darío de Regoyos (private collection). A spatula was used for this painting of a nocturnal landscape in which the artist paints the first lunar halo that he ever included in his work. He returned to the theme in later years with magnificent results. The sky looks extremely solid and the reflections of the moon on the sea have been painted with beautiful tones.

2

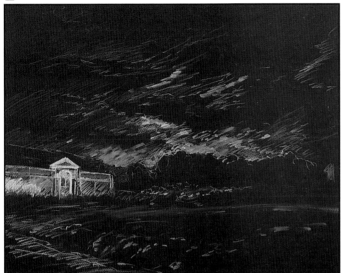

range of pink and violet colors that are made by mixing cobalt blue, white and carmine. Superimpose veils and let the black of the paper show through to recreate the transparent effect of the clouds. One thing to bear in mind is that when you work on a sky like this you should not forget how it will relate to the land below, the elements throughout the whole image must be related with the same chromatic harmony. A few touches of blue on the blanket of

grass in the foreground help to make the picture look more united. The artist moves on to add touches of red to the facade of the cemetery. Remember that artificial light transforms white and the cemetery wall is dirtied with orange and yellow tones.

Fig. 4. The artist uses cadmium yellow, permanent green and ochre on the blanket of grass in the foreground to get the different tones he needs. He paints in an impressionist way, superimposing a few short, color-saturated strokes and other more transparent ones that allow the black of the paper to show through. To represent the dark area he leaves the base blank. Remember that the background should become an integral part of the

3

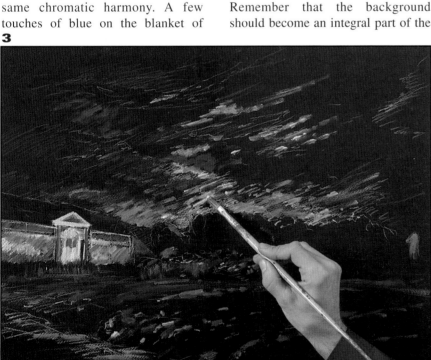

TIPS

1-. People have been saying for decades that black should never be used. In fact, black can be really useful both as a background color, and as part of the painting. Although many artists avoid using it, Manet and Renoir used it extensively.

2-. Merging can be used to create interesting textures and colors, because the lower layers of color are seen through the upper ones in disproportionate measures.

1

2

piece and you should always think about the possibilities that it offers.

Fig. 5. Go back to the background to add more details to the mass of trees. As these trees are further away from any light sources, they are as colorful and contrasted as the vegetation in the foreground. Even so, Grau Carod has

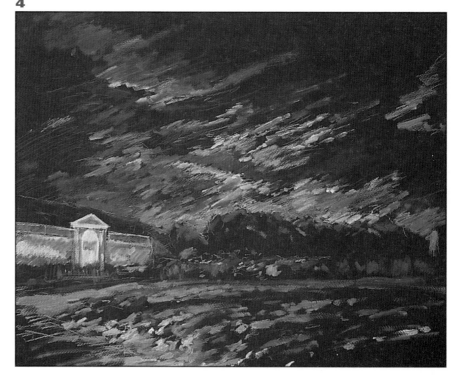

4

5

TIPS

3-. When you are thinking about the color scheme for a given painting, never forget that colors are never seen in isolation. The way we perceive a color greatly depends on the context it appears in.

4-. Using a limited range of colors on your palette is a good habit to get into if you want your paintings to look harmonious. You will be using the same colors over and over again.

3

4

and the strokes along the side of the path now cover all of the background color. With a little ochre, white and cobalt blue, apply some wider stokes to the asphalt pathway at the bottom of the picture. Notice that the colors in this section are more diffused into each other than they are in the rest of the painting.

Fig. 6. As you can see in the original model, the moon is out of our field of view –it does not appear in the photo-

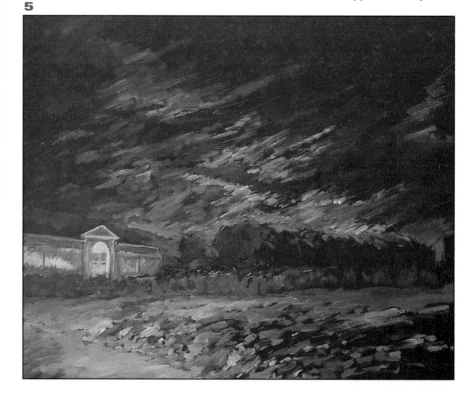

silhouetted the upper section of the foliage under the moonlight with a medium intensity green mixed with a little white. The rest of the treetops have been painted with directional cobalt blue, raw umber and permanent green strokes. None of these colors have been applied in their pure state; they are all mixed and neutralized with each other. The illuminated foreground has gradually been built up,

MODELS

2- *Moonlight and lamps*, by Léon Spilliaert (Orsay Museum, Paris). This artist suffered from insomnia and spent his nights wandering the streets of Paris finding new subjects to paint. Look at the halo of the moon in this picture and the expressive forms that suggest the vibrancy of the light and the feeling of desperation.

cently to the illuminated facade of the cemetery.

Fig. 7. There are just a few minor details to be added now. Touch up the blanket of grass near the path and finish off the group of trees in the background. If we compare this illustration with the previous ones, we will see how much more violet the sky is now, and the richly worked effects that the moon has on the clouds. The artist adds a halo of light around the moon using the same white but with a little thinners added. The changes to the foreground and middle ground are not so important. Looking at the whole image, you will find very few uniform colors, but all of the gray-greens, pinks, blues, violets, ochres and yellows relate to each other nicely to make form a strong, unified image.

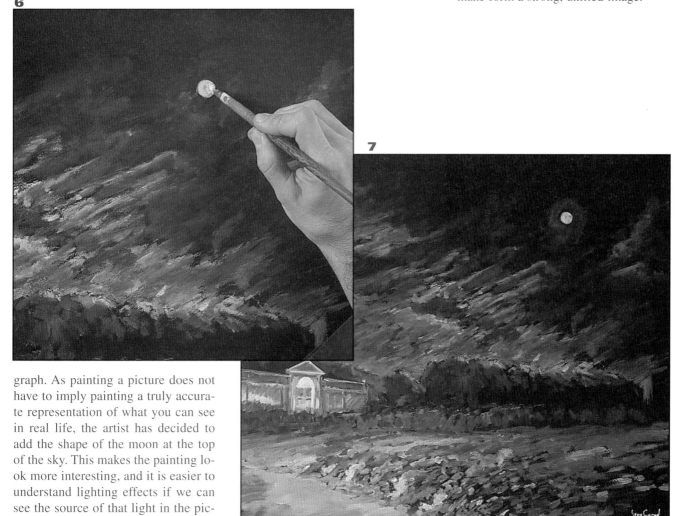

graph. As painting a picture does not have to imply painting a truly accurate representation of what you can see in real life, the artist has decided to add the shape of the moon at the top of the sky. This makes the painting look more interesting, and it is easier to understand lighting effects if we can see the source of that light in the picture. The moon also relates magnifi-

Reflections on water

Seaside towns offer a wide variety of subjects and themes for the artist to choose from. This time, the expert watercolorist Antoni Messeguer has chosen this view of the Spanish port of Palamós to

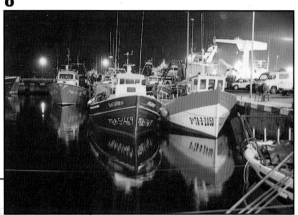

Once the boats have been drawn with a pencil, go over the lines with a small round brush and burnt umber paint.

Fig. 2. Start coloring the shadows. With the same umber that was used for the outline sketch, start painting the darker areas of the composition, leaving the lighter areas to the white of the paper. These dark gray colors that so beautifully mold the painting not only create the depth and volume that the image needs, but also form a useful base onto which later washes can be applied.

Fig. 3. When the original brown wash has dried completely, you can paint over it knowing that your colors are not going to mix together. You should work on the reflections at the same time as you paint the colors

paint the reflections of boats on the surface of the water (fig. 0). There are two main problems to think about: the reflections of the lights and the way that colors are altered by the orange hues of tungsten lighting.

Fig. 1. After working out the proportions and calculating distances, make a careful drawing of the scene. To paint a scene as complicated as this one, you will need to define the linear structure to perfection. This is the only way to be sure that your colors are being applied in right places. The drawing must be clean, with each plane properly defined with the inclusion of all of the major elements.

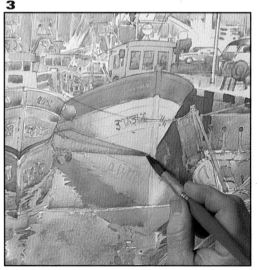

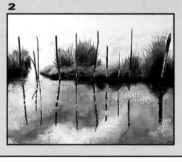
of the boats. Always remember to add a touch of ochre to your colors so that they look more orange, which is the color that tends to appear when objects are lit by artificial light. Apply superimposed horizontal lines, recreating the sinuous, wavy movement of the surface of the water and the changes of light that occur over it.

MODELS

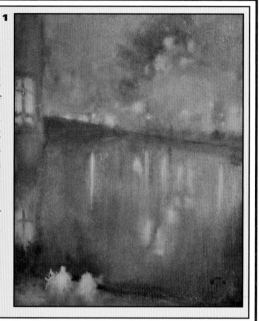

1-. *Nocturnal: gray and gold. Canal Holland*, by James Abbott McNeill Whistler (Freer Gallery of Art at the Smithsonian Institute, Washington). Rather than being naturalistic, this composition leans more towards the abstract. Notice that the bright lights that are reflected onto the surface of the water are far more intense than their source (the light from the houses and streetlights). The idea of painting wet on wet with watercolors is what has created such a vaporous appearance.

thin brush to respect the areas of light. Once the light of the reflections has been painted, lines are drawn at the bottom of the picture with darker tones. Remember that reflections tend to be slightly darker than the object they are reflecting. The same colors that were used to paint the surface of the water are now used for the sky. Paint the upper section of the picture, that which corresponds to the night sky, using wide, violet washes and leaving some areas lighter and more illuminated than others. Recreate the diffused light and the glow of the streetlights with the use of the white of the paper, diffusing the edges and adding a few specks of sepia. These effects multiply the vibrant sensation of light and colors that flicker on the crystalline surface of the water.

Fig. 6. Now you only need to finish painting the boats in the foreground; accentuating contrasts a little more and adding the last touches of detail. The artist works quite hard on the accuracy of his painting and adds several details: the cabins of the boats, ropes, masts, buoys, anchors, moorings and so on. All this is done very precisely and with somewhat darker tones that the ones he has used up until now. Once the watercolor is finished, all that remains to be said is that whenever you go out to paint the shore of the sea or a lake do not forget that reflections are present in every corner of that surface.

4

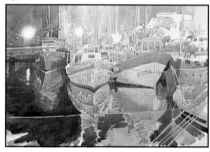

Fig. 4. Work on the reflections of the other boats in the same way. The size of each reflection should be similar to the boat that is causing it because they are just above the water. If they were further away, their reflections would need to be smaller. Notice the

detailist way in which the artist has approached the subject even at this early stage of the watercolor, achieving the richness of shades that even

5

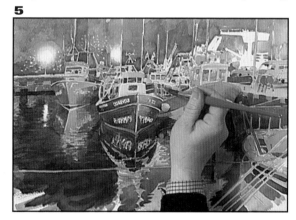

appears in the darkest areas. He now applies violet washes to darken the water and the night sky, remembering that the water needs to be colored with a darker tone than the sky. .

Fig. 5. Keep painting the textures and reflections of the water by superimposing strokes and using a

6

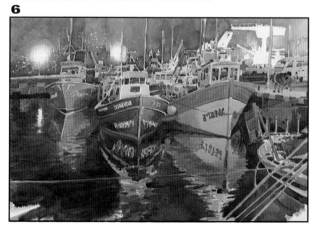

Illuminated facades: a typical English pub

Josep Antoni Domingo is going to paint an illuminated facade, this time using oils. This exercise will need particular attention to be given to the correct representation of the textures of building materials and architectural ornamentation, along with the shadows that they produce. The subject is a typical Tudor style English pub, lit by the spotlights that are built into the facade of the pub itself. Notice how simple the forms of the model are; there are several symmetrical shapes. One difficulty will be the light that is shining out of the windows of the building.

Fig. 1. As you can see, the artist uses black card as the background for his composition, meaning that there will be several areas that he does not need to paint because the black of the support will do the work for him. The first applications of color need to be fast and generalized, without too much concern for detail. Notice how he shows the blue of the sky and the main lines and areas of light around the building. This phase is completed very quickly, but by indicating the main areas of contrast, the general forms are already becoming evident.

Fig. 2. The previous step in-volved the use of dull, gray tones, but, in contrast, the next stage involves facing up to the main problem that the model presents –the spotlights and the rays of light. With yellow and cadmium red, paint the degraded light of the spotlights on the first floor, adding more yellow as you get closer to the source of light. With emerald green and Naples yellow, indicate the light coming out of the window in the second floor and the luminous sign that hangs over the entrance to the pub. The opacity of oil colors means that the transparency of your colors can work in two ways –a light, transparent color becomes opaque as new layers are added, but over a dark background like this, it becomes more luminous.

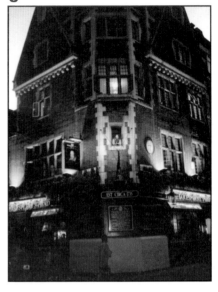

Fig. 3. The opening stage of the painting is completed with the search for the main areas of light in each section of the painting. These colors should be applied progressively and they should become more definitive as the painting takes shape. With this done, the artist turns to the architectural elements. He uses a thin brush with white and plenty of thinners to draw the forms of the windows and ledges, and works on the definition of the little tower in the corner of the building. From now on, these lines will serve as a guide to working with more accuracy. To represent the bricks in the facade, the best way is to treat it like an area of plain color and then add a few indications of texture by

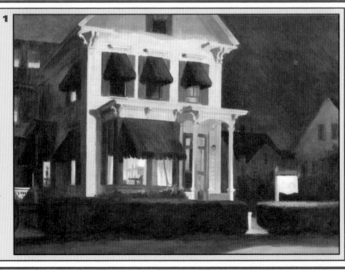

3

drawing bricks in separate groups of two or three.

Fig. 4. Once the colors that inundate the facade have been painted, one can start working on far more specific lines. The contrasts that are painted over the previous colors have brighter tones that build up the outlines of the forms and make details clearer. Thus, the lights in the windows, the reflection of the ledge and the form of the illuminated window on the second floor

tize the forms within the painting.

Fig. 5. The black background is still visible through the layers of paint. When applying the last lines you should take the color of the support into account. If you wish to take the brightness out of any given area, the outline of the last strokes needs to let the colors below show through. Do not forget that the lights in the facade and windows are bright and intense due to the contrast with the black color that surrounds each lighter area. The artist paints the moving figure at the bottom of the picture with violets, pinks and blacks. The position of the figure within the composition and the direction in which he is moving are factors that determine the way the spectator perceives the image.

Fig. 6. While the artist has been building up the illuminated facade, he has also been lightening the blue of the sky by superimposing washes that are not as dark as the ones he applied earlier. The operation concludes with the definition of specific contrasts, which make each area of the painting easier to make out. He uses colors meticulously and his strokes are much thinner and pastier than any that he has used up until now. Examples of this are the figure at the window, the flag and the letters that spell out the name of the pub. Construction materials are an important medium for highlighting the characteristics of any given place, for in many cases buildings like this one are

4

5

6

are detailed. It is important that these lines do not become too evident. Forms should emerge progressively so as too avoid making mistakes. Any details become surer as lines schema-

made using materials that are typical of that particular region. Therefore, architectonic details are a useful way of portraying or identifying the characteristic appearance of a geographical area.

View of a large city

We are now going to paint a view of a large city, and look at the problems such a topic presents: more blurred and distant forms, merging lights, rather imprecise forms and facades, and moving car headlights. The subject is this view of the river Arno in Florence, Italy, one of the Meccas of Renaissance art. For this step by step exercise, we have once again chosen to work with Óscar Sanchís, and he is going to be using oil paints. Óscar Sanchís is going to pay particular attention to the study of lights being shown as degradations to show sparkling lights, spots of light and the reflections on the crystalline surface of the river.

Fig. 1. The preparation and coloring of the painting should be fast and immediate, placing colors at the same time as forms, and therefore there is no need for a detailed sketch that explains every form that will eventually be included. As you can see, the oils are lightly diluted with thinners, but not so much that the paints become too liquid and mix into each other. The great advantage that oils have over other painting mediums is that the painting can be built up progressively, owing to the fact that both dense and diluted paints can be used. The opacity and texture of oil paints make the initial coloring of the painting a whole process unto itself, long before any final perfections are included. The colors that the artist uses at this stage are Prussian blue, black and burnt umber. The best brush to use is a flat, horsehair one.

Fig. 2. The strokes are getting progressively denser, still without too much definition, and blend colors and tones together. As you can see, the colors are applied as strokes that strive to show the horizontal nature of the landscape, leaving the areas that will be used to

1

2

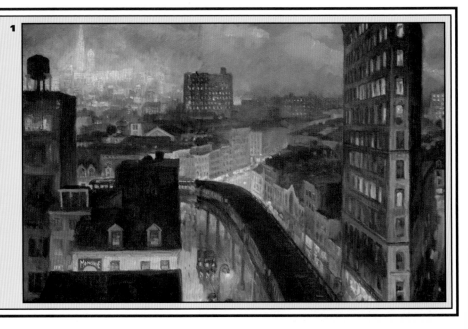

3

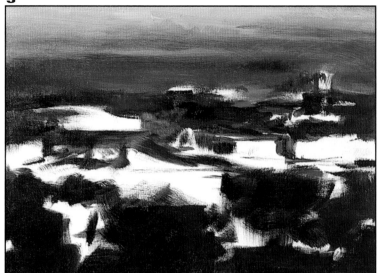

show the illuminated facades blank for the time being. The colors that are used to paint the lower section of the picture are more contrasted. Dark gray and orange have been added to the colors listed in the previous section, although the overall feel of the piece is still fairly monochrome because the artist is still concentrating most of his efforts on the darker areas of the composition. Fig. 3. Now paint the wide area of sky with long horizontal strokes of cadmium yellow, cadmium red and ultramarine blue, making sure that the co-

lors blend nicely into each other. To do this, you should use a thinner brush, which will help the different colors to merge into small degradations. When you approach the horizon, you will inevitably need to bring the blue of the sky into contact with the darker colors of the city. Let the blue of the sky merge into the silhouettes of the roofs to create a diffused horizon.

Fig. 4. No details have been added to the simplistic color layout of the composition. You should not confuse things with details until the whole of

4

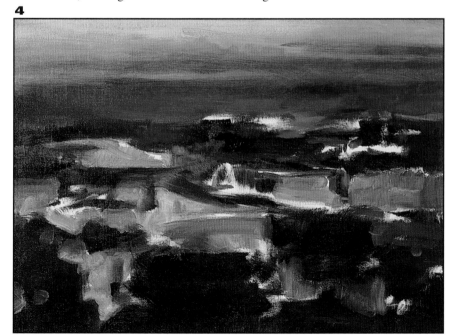

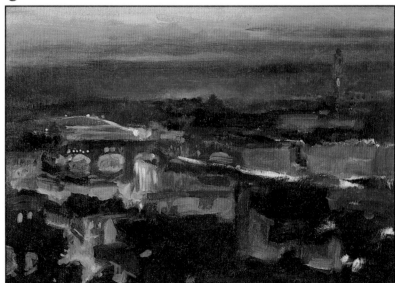

TIPS

3-. In paintings that use thick pastes, you should consider mixing directly onto the surface as well as on your palette. You can often modify tones by adding a new color to one that has already been applied.

4-. As all colors are modified by the light that falls onto them, and as there is always some kind of light, even in shadows, colors are rarely as dark as they might appear to be.

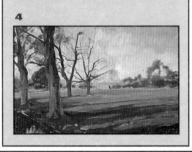

artist starts modeling and forming the bridges, facades and avenues. He paints over the colors he applied before. Notice how the artist works with one brush while he holds two more in his other hand. This is quite common practice among professional painters, because the artist can easily access the colored brush that he needs without having to waste time cleaning the brush every time he decides to change color. Look at the texture that his strokes produce through the use of short, pasty lines. If thick strokes are applied to a recently painted surface, the movement of the brush will cause the color below to move along with the new color being applied.

Fig. 6. The artist paints the lights of the cars in the street and the reflections of the city lights on the surface of the water with Naples yellow. Sticking up on the right of the picture is the tower of the palace of the Signoria, which should be painted with raw umber, orange and cobalt blue. Blend the colors of the horizon with a little cyan blue. With a small, round brush, paint the occasional spot of light with cadmium red, ultramarine blue and Naples yellow. Notice that the artist is painting from the top downwards, first painting the more distant elements such as the sky, bridge and horizon, and moving down to the foreground, which has hardly changed at all with respect to the previous stage. Colors and forms are progressively corrected. Increasingly surer strokes are painted over what has gone before as the forms of the image are built up

the background color has been applied. Therefore, the artist starts filling the brighter areas with warmer colors, namely ochre, cadmium yellow, cadmium red and sienna. There is a strong visual effect caused by the complementary contrast of warm colors next to cool ones. If you look at each of the strokes individually, the effect seems meaningless, appearing to be no more than areas of color. However, when seen as a whole, you can understand how they show the different lights of this urban landscape.

Fig. 5. Now, with smaller brushes, the

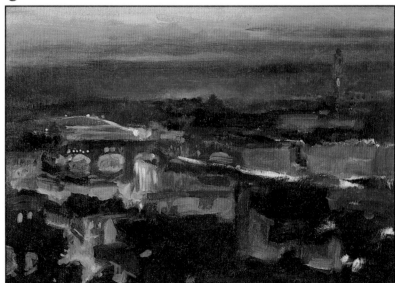

MODELS

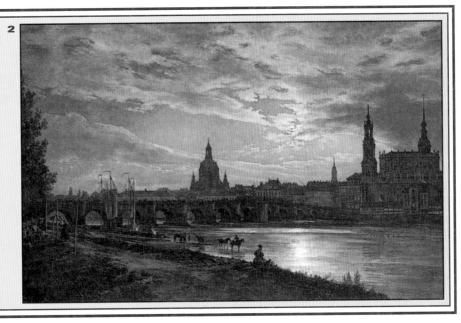

2-. *View of Dresden under a full moon*, by Johan Christian Clausen Dahl (Staatliche Kunstsammlungen, Dresden). This Norwegian artist's landscape paintings of Dresden caused a sensation, characterized by the combination of faithful representation with the romantic atmosphere that prevails in the composition. He invades the contemplative mood of the view by describing the chaotic river life with a bridge crowded with people, horses and carriages.

7

piece by piece.

Fig. 7. Now it is time to paint the foreground in more detail. Add more specific touches over the earlier colors so that the light from the doors and windows of the houses and the lights in the street can be identified. Notice how the vehicles crossing the nearest bridge have been painted as lines, rather than painting each headlight one after the other. When dealing with such complex models as this one, you need to think carefully about synthesis. You can clearly see that not all of the areas of the painting have been dealt with in the same way – in some areas the colors blend together, whilst in other they have been superimposed. When you paint spots of light, try not to let the colors mix into those underneath. To be sure that there is the minimum of mixing between these colors, carefully apply the paint without moving the brush along the surface of the painting.

Fig. 8. You only need to paint the contrasts between light and dark before you can consider the painting finished. This will help suggest shape and highlight some of the medium intensity lights. The artist has decided to paint more windows, to add new spots of light with intense colors in the middle ground and to make the tower on the right a little brighter. The result, as you can appreciate, is excellent. This view has been painted with extraordinary smoothness and there is certain sketchy feel to it, although it still manages to be a wonderful portrait because the proportions and most outstanding characteristics have been so astutely portrayed.

8

Avenues and monuments

Among the most interesting visual phenomena in modern cities are long, brightly lit monumental avenues, whose lights are often distorted and offer imposing, sometimes phantasmagoric, images of the buildings. This exercise will involve the interpretation of a simple urban landscape with a harmonious range of cool colors. Warm colors will not be dispensed with entirely, but they will not dominate any part of the image. For this exercise with are once again going to be working with Óscar Sanchís. The subject is this view of a Parisian avenue, with a monumental fountain in the foreground and an enormous classical building at the other end. The artist will be using watercolors.

Fig. 1. The outline sketch should combine an exact linear perspective with an accurate representation of the ornamental elements that characterize the monumental architecture of Paris. There should not be any shadows or excessive details, but every area that is going to be painted needs to be specified. To draw this avenue you need to consider the most important rule of all concerning perspective –parallel lines that move into the distance and meet at a vanishing point situated on the horizon.

Fig. 2. Start painting the sky with a medium intensity wash made up of three colors: ultramarine blue, cadmium red and burnt umber. Blend these three colors in an irregular way onto the wet surface of the paper. As you can

1

2

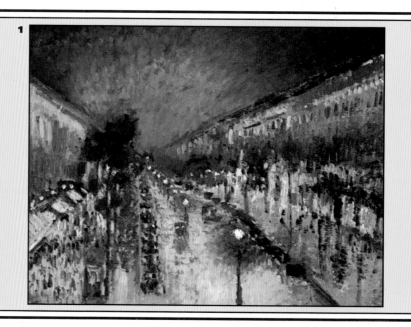

3

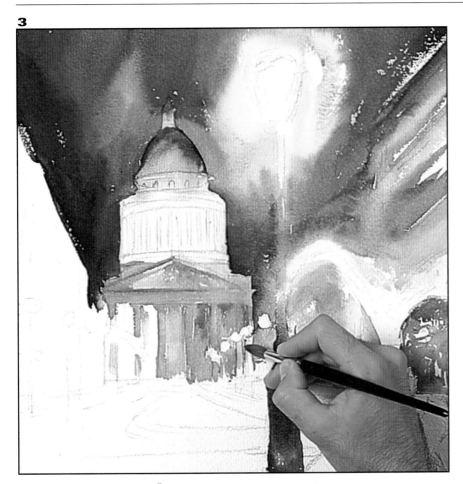

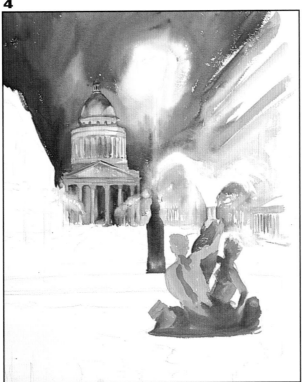

4

see, the sky appears as a wash, contributing to the blurred, scarcely defined outlines of the glow of the streetlight. Colors that are painted with watercolors should always follow in a determined order —the lighter tones and colors are always painted first and darker and more opaque colors are applied over them. The damp background allows for atmospheric effects, imprecise areas of color, blended sections and pompous colors to be added.
Fig. 3. You should now take a small, round brush to paint

TIPS

1-. If you feel that the application of a color is excessive, you can take color away when the wash is still wet. Just wait a while for the humidity to be right and use a dry brush to start taking color away. When the brush passes over a damp surface, it will absorb the paint.

2-. Paletina strokes are wide and generous, and this instrument is particularly useful for coloring wide areas. Although you may not realize it, a paletina offers a wide variety of options because it can produce very accurate outlines.

1

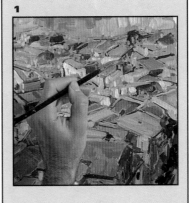

2

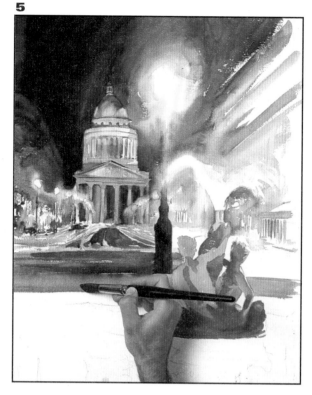

3-. The golden rule for painting buildings is to take all the time you need over the first steps. Start with a good drawing, measuring and checking every angle, curve and form, and do not start painting until you are totally satisfied with all of the proportions and perspectives.

4-. The wet on wet technique involves softly applying one color onto the damp surface of the paper or another wash to suggest spots of light and reflections on the crystalline surface of the water.

3

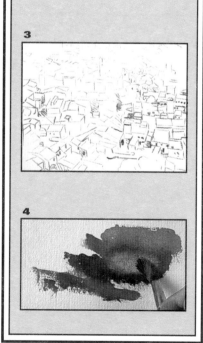

4

the classical facade of the monumental building. Take care over each architectural and ornamental feature, trying to make your representation look as similar as you can to the original. You should use mostly ochre and raw

sienna to paint the illuminated section of the facade and the same violet that you used in the sky for the areas in the shadows, such as the entrance, the ledge and the dome. The artist should develop a portrait image of a building like this, be it due to its intrinsic beauty or the color or texture that attracts our attention.

Fig. 4. After a few minutes, the facade of the building is completed. Notice how the artist has used diluted paint and has occasionally merged very diluted colors over thicker layers. The first colors have been added on wet, but the most contrasted, solid details and lines (perfectly molded into the original pencil sketch) have been painted when the layer of color below is completely dry. The complexity of this exercise is not so much related to the techniques that are used as it is to the use

and observation of the drying times of each layer of color. The artist centers his attention on the foreground as he works on the sculpture of the fountain with barely two values. Notice how he has left the stream of water to the white of the paper, which he has then modified with a very watered down yellow.

Fig. 5. Use wet on wet techniques to paint the streetlights and the asphalted street. To paint the streetlights you should apply paint to the color of the support and absorb the surrounding color (still wet) with the tip of a dry brush so as to represent the ray of light en forma de ara. The facades of the houses appear sketchy and almost abstract, and are of a similar color to that used for the sky. The sidewalks are painted with monochrome gray

6

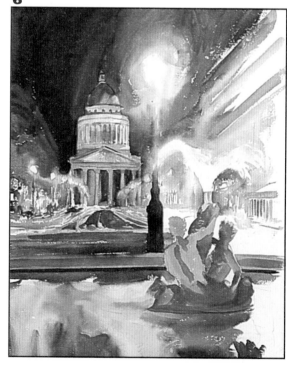

7

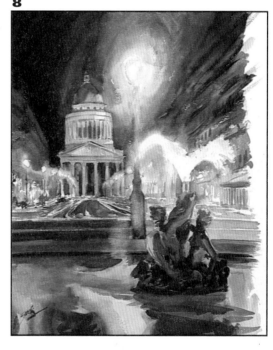

washes. Always try to relate the darker areas of the picture to the lighter and more illuminated sections. When you are painting an urban landscape like this, rather than dealing with each of the buildings and lights separately, try to find ways of capturing and transmitting the overall atmosphere of the scene.

Fig. 6. There are no areas of uniform color on the surface of the water; it has been painted with different touches of ochre, Prussian blue, carmine and sienna. These neutral colors are applied on wet and reemphasize the

nature of the nocturnal light. The surface of the water causes distortions and subtle changes of color in the lights. Reflections, like shadows, are a wonderful tool for enhancing composition, allowing the artist to repeat and echo the forms and colors of other parts of the picture. These reflections almost always have irregular edges, because even the gentlest movement of the water makes them tenuous and blurred.

Fig. 7. Notice that the violet blue that the artist used for the night sky has reappeared in other parts of the painting (the fountain, the street and the reflections on the water) to make the image more cohesive. When thinking of the color scheme for a painting, you should always remember that no color appears in isolation. The perception of any shade or pattern is always influenced by whatever it is surrounded by. With darker tones than have been used up until now, the foreground is completed. The structures of the sculpted features of the fountain are given more shape by

adding new contrasts and modeling the forms a little more, and at the same time burnt umber is used to intensify some of the reflections on the water.

Fig. 8. Just a few details remain, such as covering the white of the paper used for the facades of the buildings on the right with burnt umber and adding a few more veils that also darken

8

the overall dynamic of the painting. As you can appreciate from the finished picture, the composition is full of atmosphere and movement, the latter of these qualities being accentuated by the freedom of the strokes and the water that flows through the sculpted fountain in the foreground. Perspective is highly important in a watercolor like this, because the main effect is generated by the panoramic view of the avenue that leads up to the monumental building in the background. The intensity and color of the scene have been created by means of a series of transparent washes, superimposed to produce subtly merged colors and degradations.

MODELS

2- *Rue St. André-des-Arts*, by Pere Ysern Alié (Fontbona collection). Here is a view of a Parisian street at the end of the day. To paint views like this one of a street that disappears into the distance, one does not have to be an expert on the rules of perspective. Nevertheless, to paint the proportions of the buildings and the effect of distance credibly, it is something that has to be considered carefully. Before you paint urban scenes, you should read up on the basic rules of perspective.

After the rain: lights and reflections

A nocturnal urban landscape offers the artist a wide range of interesting chromatic effects and these are multiplied if the surface of the street is wet after a shower of rain. Countless new effects are produced by the small reflections that shine off a wet surface. We will be examining some of these lively, spectacular effects in this next exercise. The subject we will be using is this view of Picadilly Circus in London after it has been raining. This is a good example of how the damp ground presents the artist with a new challenge (fig. 0). The artist who is going to show us how it is done is Jo-

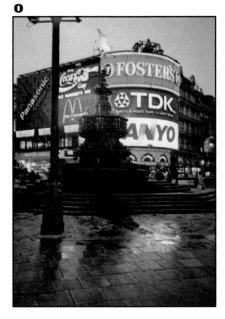

sep Antoni Domingo, and he will be using oil paints.

Fig. 1. The scene is outlined with a number 2 pencil, which can easily be erased so that any of the major elements can be re-situated if things don not look right the first time. As you draw the subject, you should start by outlining the main forms and angles. For this sketch you should not stick to just the geometric forms that portray the architectural elements, add a few architectonic details too. The sky, the streetlight and the fountain in the center of the square produce a very vertical emphasis that is reinforced by the buildings and the layout of the tiles on the ground.

Fig. 2. The first colored strokes to be

MODELS

1-. *Rainy night*, by Charles Burchfield (Museum of Art, San Diego). Rain in a city at night presents new problems to the artist that wishes to paint a nocturnal scene. I am speaking about reflections. Not only do they reflect the represented elements but also the shadows and lights that they cast. See how Charles Burchfield has painted the reflections in this painting.

3

applied are violet shades. Start working on the center, drawing the subject with short red, burnt umber and violet strokes. These first strokes are used to paint the darkest area of shadow in the picture –the central fountain, which is clearly counter-lit with respect to the neon advertisements in the background. As you can see, the artist does not use black because this would limit the shades of the other colors. Instead, he uses a dark violet mixed with dark grays.

Fig. 3. These first phases are still fairly linear. The central fountain is finished and the same color is used to cast the small shadow that spreads across the ground towards the spectator (this should be done in

the same way as the streetlight). With a little cadmium red the artist starts forming the luminous signs, doing so with a medium round brush so as to outline the form of the letters more easily. As he paints the lights on the facades, he adds shades of the same color to the floor of the foreground that gradually take the form of the reflections on the wet ground. Similarly, this time with ultramarine blue, white and a little cadmium red, he starts painting the paving stones at the bottom of the picture, each one with different tones.

Fig. 4. Keep applying the general tones of the painting, using colors that are slightly diluted in turpentine. The process of the

4

3

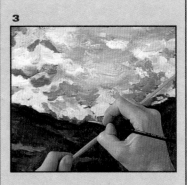

4

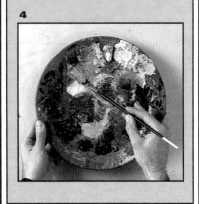

5

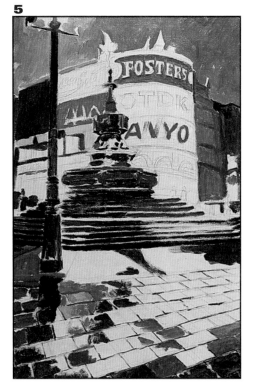

previous stage is repeated; the artist cleans his brush and takes another color (in this case blue) to paint another neon advertisement and outline the letters carefully. Once he has finished, he repeats the color, this time with a slightly darker tendency, on the paving in the foreground, thus painting the reflections and the source of light at the same time. The rest of the paving stones have also been progressively covered with color, as if, rather than painting, the artist was doing a jigsaw puzzle. The facades on the right that do not have signs on them are painted with grayish tones, with very little detail and just two values.

Fig. 5. With an unequal layer of ultramarine blue, paint the sky, taking care over the upper edge of the buildings. Paint the facade of the house on the left in the same way with a very intense claret. This operation makes the colors of the of the neon advertisements seem even more in-

tense and shiny, because a color seems lighter or darker depending on the colors around it. If a color is too thick, you can use a little linseed oil, but only in very small quantities so that the color does not lighten too much.

Fig. 6. The small touches to the floor of the foreground are continued. If you look closely, you will notice that the colors of the paving stones get more violet as they get nearer to the spectator, and the colors are earthier as they get farther away. To shade these areas you need to find the right color by mixing paints on your palette. The white surface of the support can still be seen through the paint, and the artist makes use of it to paint the color of the paving stones. Brighter colors like whites, reds and yellows are easily applied, so it is important to establish the limits of each one to keep your colors clear and pure. The use of complementary colors in the

6

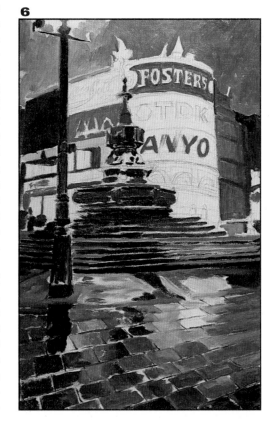

MODELS

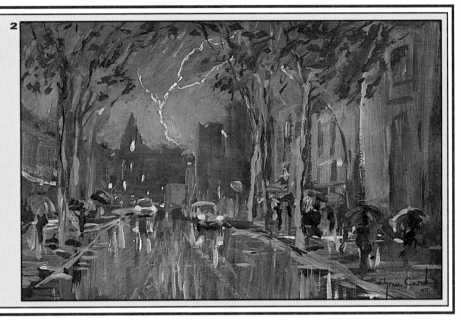

2- *Rain over the city*, by Grau Carod (artist's private collection). The storm is so strong that the artist has even added a flash of lightning to the sky. This color sketch, painted with acrylics, shows how skilled the artist is at showing the reflections of cars and pedestrians on the wet surface of the ground. To do this, he adds small, vertically applied stretches of gray color to the surface.

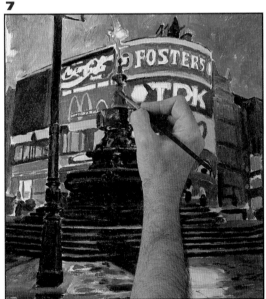

reflections of the advertising hoardings on the wet ground produces extremely intense contrasts.

Fig. 7. After completing the luminous advertisements, the background has been colored completely. And now each of the sections is defined, studying the strokes and the colors that are in used in each. Remember that new strokes will generally drag part of the color of layers below. A painting like this, one that demands such a defined finish, needs to be painted with several layers of colors, always progressing from the most general to the most detailed. Notice how the artist completes the form of the fountain. Take care over the quality of the strokes, they are not identical; some are short, others are long, while some blend into the tones below to accurately represent the ornamental forms and the sculpture that appears above the fountain.

Fig. 8. To finish, paint the white areas and the brightest shines. Do not establish too marked a contrast between the dark and light areas; let them blend gently into each other in some places, avoiding the formation of angles and pastes. New Naples yellow strokes are applied to the top of the painting, just under the streetlight, so as to emulate the ray of light that emanates from the lamp that does not appear in the actual picture, As you can see from the finished piece, the effects of light produced by intensely colored strokes can create a lot of impact. To maintain interest you should not overuse this technique.

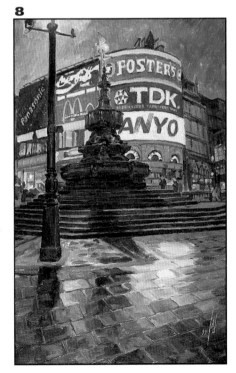

Nocturnal life: cafés, terraces and bars

All cities and towns have their characteristic nocturnal ambience, so if you are going to paint a city by night you need to capture its atmosphere and transmit the feel of the place by selecting the key visuals (fig. 0). You can try doing this alongside Óscar Sanchís and then go out and paint characteristically illuminated terraces on summer nights. Here you are not just going to be thinking about painting lights but also dealing with human figures. Novice artists often try to avoid including people in their pictures because they do not feel confident that they can paint them well enough. Do not be a coward, it is enough to just paint rough approximations without trying to produce detailed and lifelike images of each person.

Fig. 1. Start with a

decent drawing, showing a clear understanding of the subject that will form a solid base to help you work freely and daringly when you start the actual painting process. A good painting always has a schematic outline, sometimes very clear like this one, though in other cases it may hardly be visible at all, but is still there, adding rhythm and unity to the image.

Fig. 2. We start painting. The artist takes a medium round brush and loads it with a yellow that is heavily diluted in water. He uses it to paint the background, adding small touches of carmine and ochre on wet, letting the colors blend on the surface of the paper. In the same way, he uses burnt umber, ochre and yellow to paint the canopy that covers the terrace of the bar. Just like before, the artist adds small touches of cobalt blue on wet to make the surface richer in color and less uniform. The artist uses a smooth surfaced paper, which is less absorbent and does not smooth out the brushmarks, so that they become part of the composition itself. The application of washes should be very diluted because if not it would spoil the effect of the drawing and we would lose this reference.

Fig. 3. Continue applying new yellowish washes to the background, always going carefully around the edges of the figures. In the same way, use darker colors to paint the door to the bar, using burnt umber, violet and ochre. The brown washes are mixed with the red and blue ones to create the impression of a delicate shadow. As the background is wet, the tones will tend to spread. Watercolors

MODELS

1-. *Drug Store*, by Edward Hopper (Museum of Fine Arts, Boston). Shop windows, without a shadow of doubt, make a street much livelier and more animated. In this painting by Hopper, the light of the window, so full of textures, attractive colors and reflections is mixed with the light of the street.

3

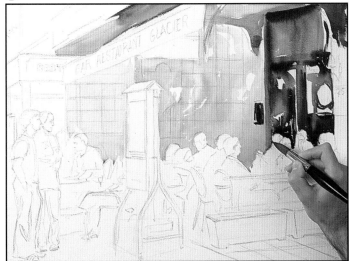

should always follow in a specific order, the lighter tones and colors are always painted first and darker and more opaque ones are placed on top. Fig. 4. With a little English red and burnt umber, the artist paints the easel in the foreground with plain washes and uses an intense Payne's gray to paint the restaurant signs in the background with extreme care. It is best to do this with a small round brush so that the letters can be outlined more accurately. As you can see,

up until now, the paint has been quite diluted and the painting has been built up by superimposing medium intensity washes so that in some areas the first colors to be applied are still visible. There does not seem to be much point in painting layers of colors that are not visible at all in the finished piece.

Fig. 5. We now paint over the initial colors. With the same brush that you used for the restaurant sign, work on the window frames with dark colors and Payne's gray. With intense colors, start painting the clothes on the seated figures. Notice how the color of this clothing relates to the color of the door of the bar. This is because no color should be applied in isolation,

4

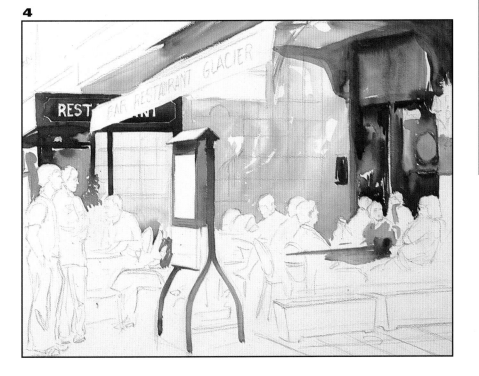

TIPS

1-. Lively colors will seem even livelier when they are contrasted with dark or neutral ones.

2-. Watercolors dry very quickly if they are blown with a warm hairdryer. By doing this, you can paint a new layer without worrying about it mixing into the paint below.

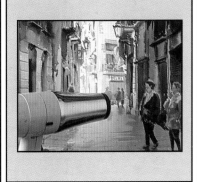

but should relate to all of the other colors in the image to create a sense of chromatic harmony. The bright, lively colors of the artificial light in this picture might not be identical to what they would be in reality, but still transmit a strong feeling of light and heat. If you want to get a clean, well-outlined design, you should avoid recreating surfaces with too many textures that could spoil your brushmarks.

5

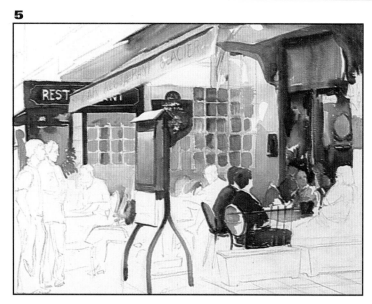

Fig. 6. Keep painting the people without paying too much attention to their facial features. At first, you may well find it hard because you are struggling with the finer details of the peoples' features and the folds in their clothes, but keep trying and you will eventually be surprised at just how quickly your drawing and painting skills develop. Human figures help the spectator to feel involved in the picture. The most important thing is that your figures look convincing.

Fig. 7. As the painting progresses, the artist becomes less general and pays more attention to concrete details. With a small brush start working more meticulously on the forms of objects, the shadows on the clothes, the reflections and textures. Modify the effect of the wood of the door with new and more intense washes and use the edge of a spatula to produce graffito marks. Within the context of shiny patterns, all of these colors could be described as neutral, but there is no opaque effect because the range and variety of grays, violets, dark grays and yellow-browns is excellent. The painting is full of atmosphere and spaciousness thanks to the colors and carefully studied postures of the figures.

Fig. 8. As you can see, the surface of the paper is now covered by the diffe-

rent washes that make up the piece. The artist has been working progressively, alla prima, and using very few superimpositions. All that remains to be done is to increase the volume of the elements by spreading more intense washes. It is important that the background color can still be seen, this is the lightest tone in the whole painting. Where it is left completely blank, the shines are white. Where the brightest shines are of a different color, they are painted in the appropriate shade.

At this stage, you can see how the background color affects the overall feel of the painting. The brightest tones need to show through between the more intense, darker tones.

Fig. 9. Each section of the painting is carefully planned. We are more inclined to think deeply about perspective when painting landscapes, but in interior paintings and views of the outsides of buildings we also need to think about the third dimension and it is still just as important to create a feeling of space. The artist does this by showing the shadows of the plant pots, chairs and people on the surface of the ground. The reason that this painting works so chromatically well is that only two complementary colors have been used: violet in the sha-

6

7

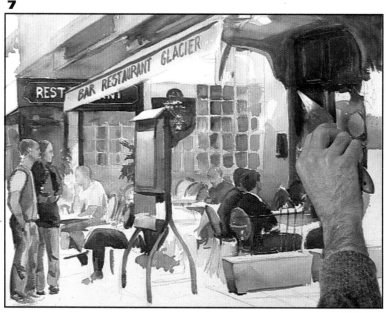

8

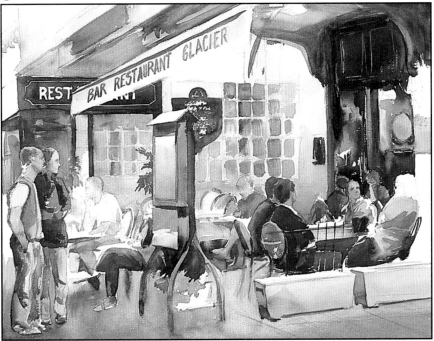

dowed areas and yellow where the artificial illumination is most evident. The red, blue, brown and green areas are more neutral and contribute to the harmonization of the piece.

9

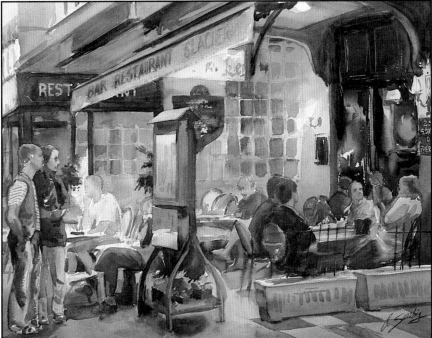

TIPS

3-. The graffito technique involves scratching the surface of the paint. We use a sharp instrument to do this while the paint is still damp. It is also a good way of opening up blank areas of paint.

4-. Superimposed, diluted, pale washes create areas of more intense color than those that are achieved with a single, plain wash with a dense color. These are ideal for suggesting the shape and volume of objects.

3

4

Nighttime market

In winter, when it gets dark early, you can often find small nighttime markets dotted around the old towns and squares of European cities. These improvised stalls blend into a background of seemingly endless lights and crowds of people looking out for new products or simply an excuse to go out for a stroll. The subject for this next exercise, then, is one such nocturnal market in the Plaza del Pi in Barcelona. As you can see from the photo, not only is the actual market important, but also the facade of the baroque building that is lit up by the lights of the market itself. The chosen artist is once again going to be Óscar Sanchís, and this time he will be using oils.

Fig. 1. After sketching the painting with the tip of a brush dipped in thinners, the facade of the house is painted with a larger proportion of yellow mixed with ochre, burnt umber and a little violet. The sky is started off with an intense violet. At first, the strokes are long and flow into each other, and it can be a good idea to add a little medium to the paint so that it is more diluted when it is applied.

Fig. 2. The general values of the lights have been painted, along with the facade and a few strokes that suggest the presence of people in the foreground, but the contrasts are still not particularly accentuated. With a medium brush and a little of the same

1

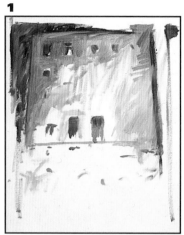

violet that was used on the sky, the openings in the building are painted. Notice that the facade contains a tonal degradation: the central section is lighter while the orange-sienna color used nearer the top is much darker.

Fig. 3. If the contrast between shadows and counter-lit sections is increased, the shapes and volumes are much clearer to the eye. To do this, the artist darkens the sky with a mixture of violet and burnt umber. He

0

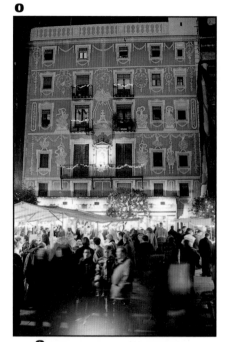

2

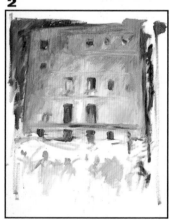

uses the same color to put more contrast into the doors, windows, ledges and balconies on the facade of the building. He does the same to the crowd of people in the foreground, although they are drawn quite roughly, as if the foreground were out of focus. The way he applies lines and strokes helps to suggest the depth of each of the planes that make up the composition. In the foreground, each stroke is applied directly to define the plane of the object being painted.

Fig. 4. It is better to finish the background before dealing with the foreground. With this in mind, the artist takes a small brush and details the architectonic decoration on the facade.

MODEL

1- *Leaving the theater*, by Carlo Carrà (private collection, London). The main subject of this painting is the movement of the figures and the vibrations provoked by the artificial lighting. This light has been painted in the form of sparkling touches of paint that cover the whole painting. If you look at the streetlights, you will see how they seem to give off sparks, as if they were flares.

3

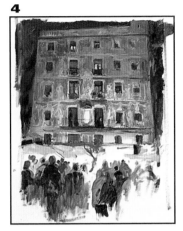

4

He darkens the wall with sienna, reserving the background color and he carefully paints the door and window frames, the ledges and the sculpted features. With a thinner brush and an intense violet, he paints the railings on the balcony, and with a flat brush and Naples yellow he adds a few touches of light to the doorways and windows to suggest the light that is shining from inside. In the center of the facade, he leaves an area white to paint the sculpture that is so brightly lit by direct lighting.

Fig. 5. As we get nearer to the foreground, the contrast with the figures increases, and it will therefore need to be painted with more intense colors. The people are silhouetted, clearly counter-lit, over the illuminated background of the canopies of the market. The light on these canopies is painted with Naples yellow, pink and ochre. The people behind are slightly better lit and their tones are grayer, whilst those in the foreground, being more silhouetted, appear blacker. These people should be painted *alla prima*, with no need for identifiable facial features. Their silhouettes should not be precise, but somewhat blurred to help transmit a sense of movement.

Fig. 6. All that is left is the progressive increasing of the contrasts with small strokes that accentuate tones, and at the same time define the nearer planes, and link the two main planes of the composition. You need to adjust the tones to their final states, thinking about the harmony of the piece as a whole, and painting the less important features such as the lights of the little balcony, the illuminated sculpture, the silhouette of the tree in the center and the darker lines on the canopies. The finished appearance of this painting should look fresh, so there is no need to add any more stokes than are fundamentally necessary, and you do not want the colors to merge into a muddled confusion.

5

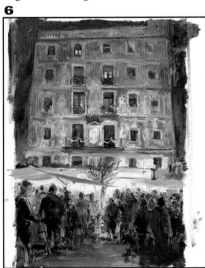

6

The illuminated still life

We are now going to transfer the effects of artificial light to the illumination of a still life. In this step by step exercise, Ester Llaudet is going to paint a group of different objects with textures like metal, glass, leaves and wood, all under the direct light of a lamp that offers an intimate character to the image along with an interesting array of shadows and reflections (fig. 0). It is a good idea to use simple lighting, preferably with just one bulb. The inclusion of the source of light as part of the image can produce extremely attractive results. This particular model includes very little chromatic variety so that we can work on the values of the tones as they

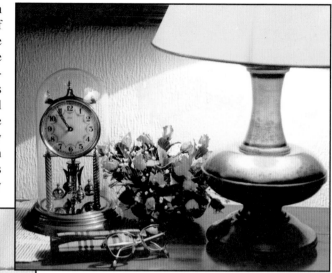

0

1

are affected by incandescent light. The artist is going to use watercolors for this exercise.

Fig. 1. As in all watercolors, an outline sketch forms the basis to the composition. It is started generally, taking good care over the proportion of each of the elements. As you can see, the drawing is highly simplified, and necessarily clean and full of imprecise forms. Once the drawing is complete, the artist starts painting. The first washes are applied, the lampshade is covered with a medium intensity, cadmium yellow wash, which can be completely uniform when it is applied.

Fig. 2. The artist has now painted the base of the lamp, doing so with more orange colors where the light shines directly and Payne's gray at the bottom. She reserves a few blank spaces of white paper that will represent the reflections on the smooth metal surface. When you paint still lives like this, just as important is the adjustment of the color of objects as is the reproduction of the textural effects that make up the materials that the objects are made of. The whole process is carried out continuously and before of the colors have had time to dry.

Fig. 3. We are now going to work on the medium tones. With a uniform wash of intense orange, we paint the part of the table just under the lamp. With the same color, we add a few darker touches to the metallic base of the lamp to give it more shape. Still using the same color, now with the addition of a little violet, we paint the ray of light, always wor-

MODELS

1

1- *Emerald light*, by Carolyn Brady (private collection). There is also a table lamp in this almost photographically perfect watercolor. Notice how the white of the paper appears in some areas where there the light is most direct. The rest has been painted with tonal shades that get darker as the objects get further away from the source of light.

2

king on wet. Although the contrasts in the shadows of the lampshade on the wall produce violet tones, by mixing that color with orange and yellow we can create a warmer shade. The value for the metal base of the lamp is produced with shades of the same color, always keeping the area of light as our reference for volume.

Fig. 4. Look carefully at the detailed variations, in particular the perfect gradation of tones that produces a systematic and gradual change of tones on the surface. The artist takes a medium, round brush and starts painting the objects that make up this still life. With a few lines, she defines the volume and texture of glass. A

3

TIPS

1-. When you have a group of objects to paint a still life with, experiment with different angles and directions of light. Do not decide on any one option until you have examined every other possibility.

2-. The color of the paper determines the brightness of the paint. Remember that if your tones are too dark, they lack transparency and annul the effect of the paper. These tones should only be used in the darkest areas of the image.

1

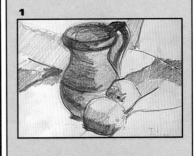

2

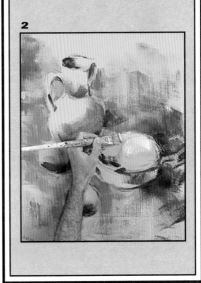

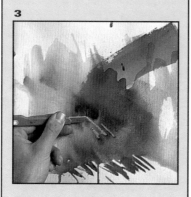
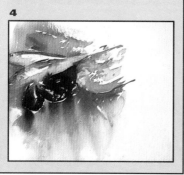
transparent burnt umber wash should suffice at the bottom, you should use sienna for the semi-spherical top. These strokes really do need to be careful and repeated so that the object presents the right curvature. To recreate the effect of glass, the background color must always be dry, if not the edges would diffuse and appear im-

4

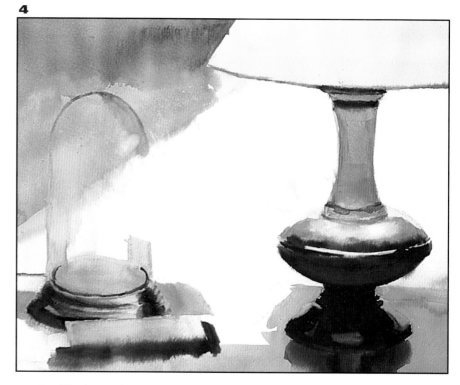

precise. The base of the clock is painted with burnt umber and ochre strokes. As the artist progresses, she adds shadows to the bases of the objects with Payne's gray.

Fig. 5. With a small brush, paint the

5

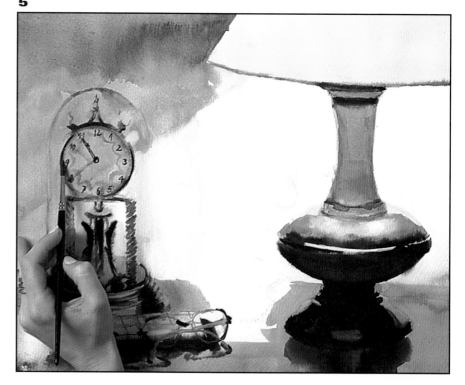

mechanisms of the clock and the glasses at the bottom of the picture. The colors used for this operation are the same as the ones that the artist has been using throughout the whole painting process. To shape the objects

6

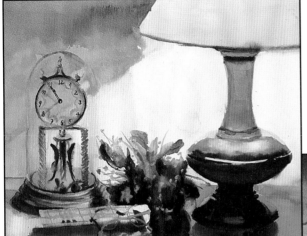

lized with a little Payne's gray, thus ensuring that the colors are not too strident and keeping the harmony of the image. As you can appreciate, the flowers have been painted in an im-

pressionist way, with large areas of color and little attention to detail. Without using too much paint, the lighting effect produced by the lamp is adjusted over each of the elements. Fig. 7. Finish the bunch of flowers by adding reddish colors to highlight the petals, but notice that they are not too elaborate and include little more than

7

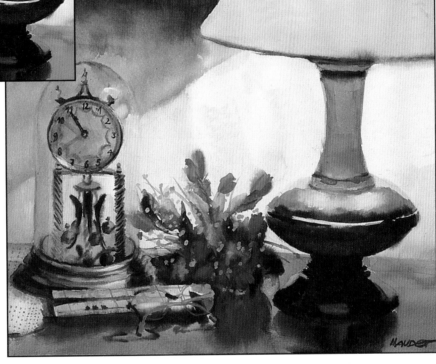

correctly, you need to take care over how your tones merge. The amount of dampness in the colors will be a decisive factor in controlling the merging properly, although if you want to apply darker tones over lighter ones, you are better off doing so over dry. To paint the reflections of light on the glass of the clock, the artist has painted a wash with a clean brush. As you can see, she paints with warm colors, although use is also made of violets and grays to cool and darken shadows.

Fig. 6. Finally, she paints the bunch of flowers with permanent green and a little carmine that has been neutra-

two main values. With a little gouache white, you should paint, in the form of small dots, the small, white flowers. If you look at the image as a whole, you will see that the shadow of each object varies with respect to tones depending on its color, size and distance from the source of light. And that is where we can end this watercolor exercise, in which shadows and the white of the paper have played such a fundamental role.

MODELS

2

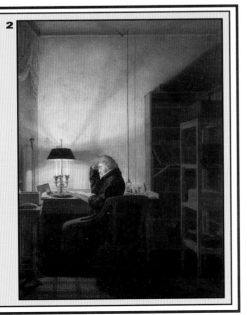

2- *Youth reading under the light of a lamp*, by Georg Friedrich Kersting (Winterthur Foundation). The light that the desk lamp projects onto the bare wall create strange, shadowy forms that the artist paints with gradations of the same color. In this painting, the lamp becomes the external expression of interior lighting. In the Romantic period, this idea evoked a sense of freedom.

Light in interiors

Just as happens in landscapes and urban paintings at night, an interior view can be used as a background for different human activities or as a theme in itself. Artificial light causes more problems than natural light in interiors because different shadows are juxtapositioned and lighting effects are sharper and more exaggerated. We will be finding out about this in this next exercise, in which Josep Antoni Domingo is going to be working with acrylic paints. The subject we will be painting is this interior view of a pub, in which several people are sitting around a table.

Fig. 1. If an outline drawing is important for oil paintings, for this exercise it is absolutely crucial. The outlines need to be exact, to be developed later

we can now start adding color to the clearly defined areas. So, paint the red walls with a bright cadmium, leaving gaps of white paper where you are going to paint the people and lights. Paint the tablecloth with ultramarine blue, you will be able to weaken this color with less intense colors later on. With dark blue and violet, start coloring some of the people's clothes. As you can see, at least at first, the colors are quite plain. There is little evidence of degradations or values.

Fig. 3. Keep painting the image with a medium round brush without even trying to express volume, except by adding a few shadows to the floor (they should be slightly greener in the foreground and redder under the

with colored lines, and for the spaces between to be filled with color. This preparatory sketch should be painted with an instrument that can be corrected easily, such as a pencil, charcoal stick or even the oil paints themselves.

Fig. 2. Thanks to the accurate outline sketch,

3

chairs, where they need to appear more distant) to enrich the chromatic scheme of the painting. Your washes should be plain and covering. At this early stage, as you are working with clean colors, you are should avoid mixing on the paper as much as possible (all of the colors have been combined on the artist's palette), and black has not been used at all. Although the artist works quite loosely, he has taken care not to touch the area of white paper that has been left for the figures.

Fig. 4. The artist continues covering the blank areas of paper with new opaque colored washes. With olive green and emerald green, he paints the jackets on the sofa in the middle ground. With a dark violet, he paints the trousers that the person sat with his back to us in the

4

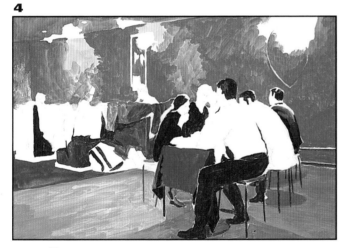

5

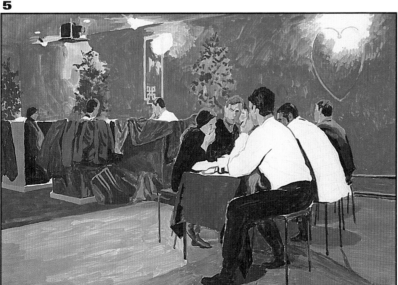

TIPS

1-. The way in which people behave can clearly express a given situation. When you watch a group of people, study the characteristic movements and gestures they make. You can express the relationships between people by using visual gimmicks such as a body leaning towards another or an arm being placed around somebody else's shoulder.

2-. If you have kept any sketches of people walking in the street, you might like to use them as a base for a new painting, combining the different figures in new ways until you find a composition that interests you.

1

MODELS

2-. *The experience of the pneumatic pump,* by Joseph Wright of Derby (National Gallery, London). The painting includes strong central lighting around which the people are assembled. The lights under the face of the portraited person make his facial features much more pronounced than they would be under natural daylight or zenith lighting. It is interesting to note what happens to the light as it passes through the glass of liquid on the table, a useful tool that avoids dazzling the spectator.

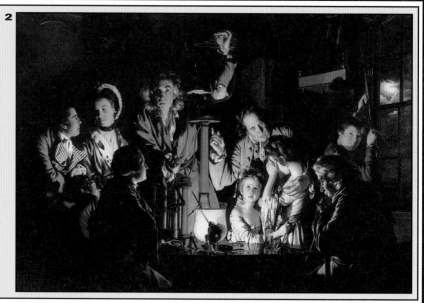

Fig. 5. Once the painting is completely full of plain colors we start working on volume and the contrasts between light and shadow. With dark green and violet, the folds in the jackets on the sofa in the background are painted. The plants on the wall are painted with a medium intensity brown and a little ochre-yellow is used to finish outlining the baseboard and the decorative parts of the wall. With a thin brush, we return to the facial elements, studying those forms that characterize personality. These lines need to be thin and accurate.

foreground is wearing. With the same violet color, he paints the chair legs with thin lines and the hair of the people around the table so that they appear in slightly darker tones to the rest of the picture. The visual effect between warm and cool colors is full of the force of complementary contrasts. The artist can afford to exaggerate the colors a little as long as they are related to the other tones in the picture and consider the light that dominates the scene.

Observe how the people's facial skin seems redder than it would do normally. The background red is replicated in their faces and helps to create a warm, intimate atmosphere.

Fig. 6. Look at the shadow of the table that is cast on the floor in the foreground. You will see that it looks rather green, owing to the reverberation of the red in the wall that appears in the general lighting of the pub. The color of the shadows of red light tends to include its complementary color, green. The yellow in the lights, on the other hand, produce more vio-

lors that tend towards a certain chromatic harmony in the piece and the carefully studied postures of the people. The faces of the people are painted in sections that are applied over the previous colors; each new area corresponds to a different plane, a new piece of modeling, and a softer contrast.

Fig. 8. A good painting like this always has an established drawing scheme, and in many cases, such as this one, it is very evident. In other cases, it is scarcely visible, but is still strong enough to lend rhythm and

TIPS

3-. A figure seen in the distance is normally suggested only very generally, with just one or two strokes of color, but people seen more close up, like these in this exercise, must be painted in much more detail.

4-. The definitive contrasts can be left until the end of the painting. So, you can add shades that enrich the general color without necessarily having to be definitive.

8

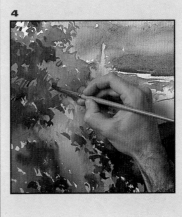

let shadows that you should be able to see just under the chairs and on the shadowed parts of the sofa.

Fig. 7. The artist now works on the textures and designs of the jackets that the two people with their backs to us are wearing. Notice how the person with the white shirt's back reflects the red color of the wall. These reflections appear in other parts of the room, such as the people's faces, the light on the floor, the jackets on the sofa and the figure in the left of the background. All this causes the picture to ooze with atmosphere and there is a feeling of spaciousness that comes from the reflections of the co-

unity to the image. As you can see, the diffusion of shadows, the result of strong central lighting or of a series of lights from above, is characteristic of the kind of artificial lighting that is so common in interiors. If you compare the original photo with the finished painting, you will see how the artist creates a certain atmosphere by changing or modifying the colors of the image. Not only that, but he has also eliminated or made more tenuous those colors that he does not feel help with the overall effect.

Interior with a figure

The representation of the human figure is one of the most stimulating artistic disciplines, and one that has always fascinated artists. It is an important subject to master, and one that demands developed observational skills, as well as a high degree of technical skill. In the next exercise, we are going to paint a female figure lying on a bed. Although she is undoubtedly the most important element in this illuminated interior, the effects of the light on the folds of the bedspread also play an important role in the composition. This is going to be an interesting exercise for studying the effects of artificial light on both the human face and a sheet of folded cloth. For this final exercise, we are going to be working with the artist Josep Antoni Domingo, and he will be using oil paints.

Fig. 1. The artist is going

to use a very unusual composition for this picture, he positions the face in the upper left hand section so as to leave more space for representing the effects that the light produces in the irregularities of the bedspread. By using the bedding to position the figure in the composition, he has created the illusion of movement in an apparently static image. The preparatory drawing is made with charcoal so that the lines can easily be adjusted an corrected. Make sure that the drawing is correct before you apply any color.

Fig. 2. Up until now the figure has only been approached in drawing form –she is only represented as a series of lines. The artist makes these initial lines a little stronger by going over them with a brush and a tiny bit of color. It is no coincidence that he opts to use indigo and violet, the artist's method involves starting with intense colors and modifying them as his work progresses. These lines must be clear and accurate so that not only

MODELS

1- *Jurisprudence*, by Edward Munch (Nasjonalgalleriet, Oslo). It is important to model the form of the figure by basing your work on tones and colors that are reflected on the surface of the skin. When modeling figures, you should always remember that shines, colors and shadows depend exclusively on the rays of light that illuminate them.

3

they, but also the shapes that they encase, can be developed later. When he has finished outlining the forms, he applies the first copper values to the hair.

Fig. 3. The colors of the skin have been constructed with a series of superimposed colors which have been diluted in a little medium. These initial colors divide the face into areas of light and shadow, and the forms are then rounded and softened, and the colors are gently mixed until the skin takes on that transparent appearance. Each brushstroke further enhances the youthful qualities of the model. In the modeling of the forms of the face, the colors of her skin should not be based on a fixed palette, because they depend on the colors of the light that surrounds the figure. Notice how the hair echoes the orange color at the top of the picture, drawing the two areas into harmony.

Fig. 4. After darkening the upper sec-

5

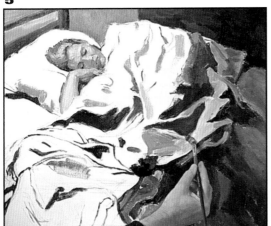

tion of the painting so that the figure stands out from it, start coloring the bedspread. The shadowed areas are painted as single blocks of color, with plain strokes using dark grays, umbers and blues. These first tones form the base for the tones of the colors we are going to superimpose later on. Detail the figure's face with a small brush. There is no skin color in itself, but you can get the right shade by mixing Na-

4

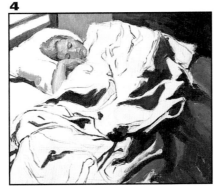

ples yellow, cadmium yellow, cadmium red, white and a touch of blue where there are shadows. Given that the background appears orange and artificial light tends to make bodies look more orange, you can add this color to the face.

Fig. 5. Work on the study of areas of light and shadow on the sheets. Cover the white of the canvas with layers of different tones depending on how much light there is. Use ochres and beige for the lighter areas, violets and dark grays for the gentler shadows, and blues and burnt umber where it is almost completely dark. When you have to paint planes in different tones of the same color, you will need to mix the colors on your palette. On the other hand, when you are combining shades and contrasting small areas of a single plane, you should do your mixing directly onto the surface of the painting.

MODELS

2- *Singer with glove*, by Edgar Degas (The Fogg Art Museum, Cambridge). There is a ghostly appearance in the facial features of the singer, caused by the lighting coming from below. This darkens the eye cavities, the top of the nose and the chin. The direction from which light is coming will determine the appearance of a person's face.

Fig. 7. Although one of the main effects of oil painting is based on heavy strokes, it is also true that one of the

Fig. 6. Once your brushstrokes have completely constructed the main forms and folds under light and shadow, use a pointed brush to outline the sharpest contrasts within both the darkest and lightest parts of the painting. The composition is now at the intermediate stage of definition. The colors and tones, although they will still need some modification, are already forming a solid enough base for you to start thinking about details. The perfectly defined planes are separated by the tones in each section. Notice how the strong orange color in the upper section contrasts strongly with the brown and blue tones in the rest of the composition.

most remarkable characteristics of oils is that strokes can be made invisible by the careful merging of colors. The colors that were used for the folds in the bedspread, which in the last illustration could be seen as different strokes, have subsequently been merged to form sweeter contrasts. The best way of merging colors involves

dragging the brush along the border between each. By doing this, the tones of each stroke are degraded and the transition between colors becomes less evident.

Fig. 8. The most pronounced shadows now need their tones increasing slightly, and a few other contrasts need perfecting before the face and arm can be considered finished. Now is the time for recreating the texture of the hair and touching up the lower part of the nose and the mouth. A portrait is not limited to just a study of facial features, you need to portray the character and atmosphere that goes with the person.

Fig. 9. To finish off this painting, you need to center your attention on the main areas of light in each section of the image, and also the most important contrasts that most define each of the different parts. The undefined texture of the bedspread has been painted with a blurred ochre and directional strokes that describe the forms of the folds. The colors and tones of the folds in this material have been constantly modified.

Fig. 10. One's eye moves across the surface of the painting in search of folds and curves, moving from the bottom right up to the top left, where the model's face

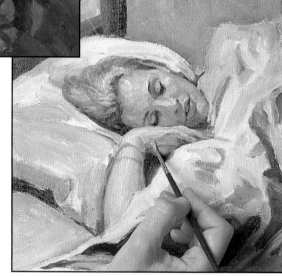

9

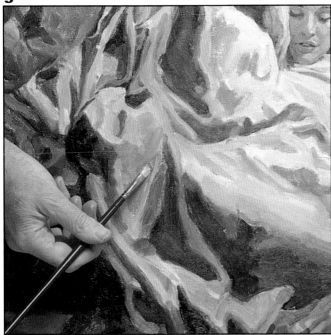

appears. In this painting of a female figure, Josep Antoni Domingo has managed to create a lifelike representation in which the atmosphere is dominated by the shadows that are cast by the light at the top of the bed and by the features on the model's face. The result is a realistic and convincing painting that has been developed from the solid base of a carefully drawn sketch. You need to learn to do the same.

10

TIPS

3-. When adding tonal values, it is best not to use black for darkening, because this color dirties the others around it very easily and can cause cracking as a result of it having a very different drying time to other colors.

4-. When painting a figure's skin, do not start by mixing one color and applying it to canvas in the fragile hope that the other colors will harmonize with it. You should mix a pleasant range of dark, light and medium tone colors on your palette beforehand. This will give you a good base to work with, and you can the lighten and darken those colors when you come to perfect the painting.

3

4

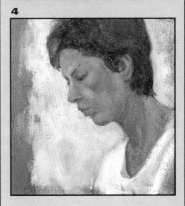

Acknowledgements

The author would like to thank the following people and companies for their help in publishing this volume of the *Effects and tricks* series.

Gabriel Martín Roig for helping with the writing and the general coordination of the book; Antonio Oromí for his photography; Vicenç Piera of the Piera company for advice and orientation concerning painting and drawing materials and utensils; Manel Úbeda of the Novasis company for their help with the edition and production of the photosetting and photostatting; Olga Bernard, Ani Amor, Óscar Sanchís and Eva M.ª Durán for granting us permission to use several photographs that were used as models for painting, and a special thanks to the artists Jean Diego Membrive, Josep Antoni Domingo, Antoni Messeguer, Grau Carod, Óscar Sanchís, Ester Llaudet and Teresa Trol.